WEST SIDE
KANSAS CITY
MISSOURI

WILLIAM J. CRAIG

AMERICA
THROUGH TIME®
ADDING COLOR TO AMERICAN HISTORY

This book is dedicated to Dorothy Devaney, who grew up and worked on the West Side, and to Jerry Michael Devaney, who had a deep appreciation for the way life was once on the West Side.

We can't have old days back, when we were all together.
But secret tears and loving thoughts.
Will be with us forever.
Tenderly we treasure the past.
With memories that will always last.

America Through Time is an imprint of Fonthill Media LLC
www.through-time.com
office@through-time.com

Published by Arcadia Publishing by arrangement with Fonthill Media LLC
For all general information, please contact Arcadia Publishing:
Telephone: 843-853-2070
Fax: 843-853-0044
E-mail: sales@arcadiapublishing.com
For customer service and orders:
Toll-Free 1-888-313-2665

www.arcadiapublishing.com

First published 2019

ISBN 978-1-63499-103-2

Typeset in Mrs Eaves XL Serif Narrow
Printed and bound in England

INTRODUCTION

A large bluff that overlooks what would become known as the Missouri River was first discovered on September 15, 1806 by Lewis and Clark when their expedition stopped on their return from the Pacific Ocean. Meriwether Lewis noted in his journal that the site offered a "commanding situation for a fort." As French Fur Traders began travelling the rivers of the region, a French Missionary Church was built in the early eighteenth century. This was the oldest structure known to have been built by Europeans in the area. The first recorded church was built in 1822 at the behest of François Chouteau, who is credited as the founder and first Euro-American settler of Kansas City. The Bluff area formally became a burgeoning residential area when Kersey Coates built his home at 10th and Pennsylvania in 1857.

After the Civil War, Kansas City began to spread out beyond the hills overlooking the Missouri River and was in the early stages of becoming a metropolis. Kersey Coates built an Opera House on the northwest corner of 10th and Broadway. This location was remote and resided outside city limits. By the 1870s and 1880s, the city expanded and began to surround the Opera House. With this rapid growth, the elite of the city began settling on the northern portion of the West Side on the Bluff. The area was first called "silk stocking ridge" and later permanently named "Quality Hill." This was the most expensive neighborhood in the city. Many of the city's leaders and captains of industry lived here. This was due to the close proximity of their business interests in the West Bottoms.

The land south of the Bluff was owned by William K. Mulkey, a North Carolinian who built his home on land inherited by his wife, Catherine. Her father was Major Andrew Dripps, a mountain man who was married to an Oto Indian. Major Dripps died at the Mulkey home, which was the only home of quality between Westport and Kansas. In 1869, Mulkey platted part of his land as an addition to the city. It extended from 13th to 16th Streets along the Bluff, north to south. The lots bordered Dripps Avenue, later renamed Belleview Avenue, on the west Catherine Street, later renamed Madison Street in the center and Summit along the east side. The lots were sold for as much as $1,000 each. This area would become the first modern suburb of Kansas City.

For the next forty years, the area flourished. After World War I, however, most of the original families who moved into the area had relocated south to newer neighborhoods. The next influx of new residents were working class, who resided in the area until the early 1960s. During this time, the area went into rapid decline. Many of the once majestic homes were either divided up into rooming houses or completely abandoned. Many of the properties were condemned by the city and torn down. The Missouri Highway Department even laid claim to several blocks in the heart to the Bluff to build I-670. They bought up properties and tore down homes to make room for the project. All this was done in the name of progress, with no eye towards saving the history of this section of the city.

What remains today are quaint tree-lined streets and beautiful brick homes with eclectic architecture. The local groceries, drugstores, and barrooms are gone. They have been replaced with coffee shops and bistros that pride themselves in using farm-to-table produce and unique wines. These neighborhoods have seen a resurgence in the last twenty years.

ACKNOWLEDGMENTS

I would like to take this time to thank my wonderful wife, Charlene, and my two beautiful daughters, Meadow and Danica, for their love and support while attempting to complete this project. Secondly, much appreciation to Dorothy Devaney and Mike Devaney for the photographs and enthusiasm in this book. Thank you to Zachary Daughtrey Diocesan Archivist for his help with the research on the Catholic Schools and Churches. Also, a debt of gratitude should be extended to the folks at the Missouri Valley Special Collections room at the Kansas City Public Library, as well as the staff at the Kansas City Museum, and the Kansas City Star for their expert knowledge and last but not least Peter and Teresa Robinson, who were extremely gracious to a perfect stranger.

1

WEST SIDE KANSAS CITY, MISSOURI

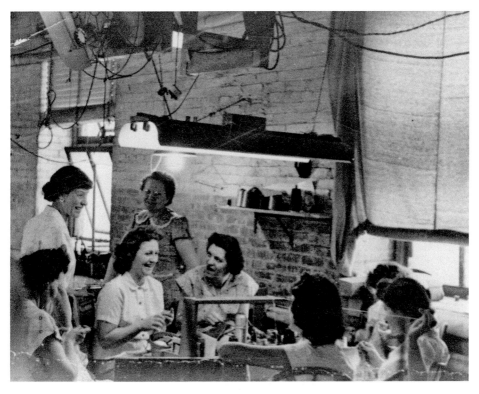

Here we see workers at Fashion Built taking a break. The working conditions in these buildings were hard to imagine. None of these buildings had air conditioning, and during the summer, large industrial fans were brought in to blow the hot air out of the windows. The temperature in these buildings would reach on average around 100 degrees in the summer.

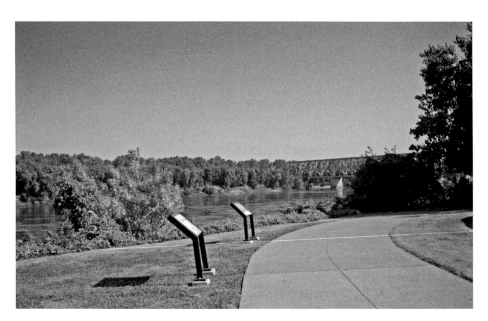

Richard L. Berkley Riverfront Park was dedicated in 1998, and opened to the public in 1999. The 17-acre park is located on the south bank of the Missouri River between the Kit Bond Bridge and Heart of America Bridge. The area was once a landfill for construction debris and the former site of a sand and gravel company. The park also boasts a mile-long esplanade with period lighting. The trail is lined with several historical markers, outlining the history of the first settlement in Kansas City then named the Town of Kansas.

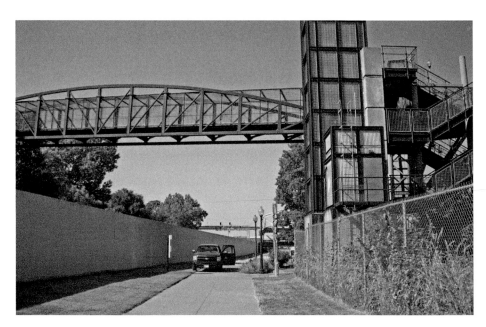

This is the Town of Kansas Bridge, which provides a link for pedestrians between the north end of Main Street and the original birthplace of the city. Pedestrians can observe the archaeological remains below the bridge. A view of the original stairs that once brought thousands of riverboat travelers to and from the area can still be seen as well.

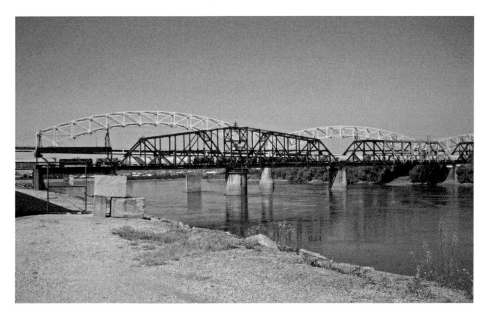

This is the approximate location of the original rock ledge, which was a natural riverboat landing that aided in the development of the Town of Kansas. The Bethany Rock Ledge was rediscovered in 2003, after the River Park was redeveloped into a pedestrian way.

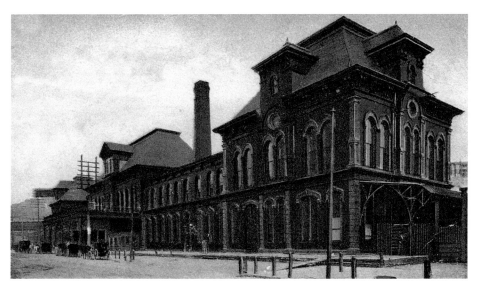

On April 7, 1878, Union Depot opened in the West Bottoms near the stockyards and meat packing plants. The Depot was built at a cost of $410,028 and was the largest west of New York. The 348-foot-long building was modeled after a French château with a blending of Gothic and Victorian traditions. The design showcased steeples, towers, arches, and a 125-foot four-sided clock, which critics referred to as "Kansas City's insane asylum." The Depot housed express offices, restrooms, and a restaurant, all of which were adorned by luxurious woodwork. Two years later, the building was expanded at a cost of $224,083 to handle the growing population of Kansas City. On October 31, 1914, the last train pulled out of Union Depot a day after the New Union Station opened. The Depot building was razed in 1915. Today, the site is a vacant lot.

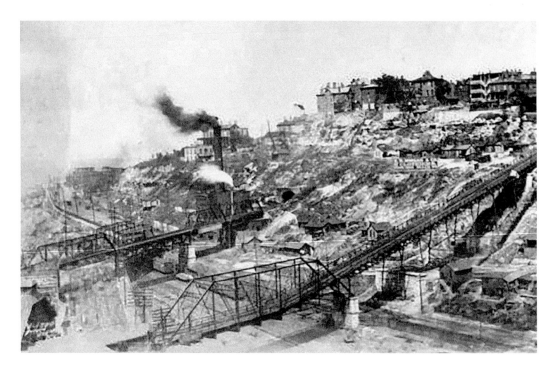

This photograph is of the incline trolleys that transported people to and from the West Bottoms to Quality Hill and the rest of Kansas City. When Robert Gilham arrived in Kansas City in 1878, he conceived his incline project, which was hailed as a triumph once completed. However, when he developed another plan for a competing rail company in 1887, his idea was labeled as absurd by locals. He capped his engineering career with the construction of the Kansas City, Pittsburgh and Gulf Railroad and its terminus at Port Arthur, Texas. He then became General Manager of the railroad before his death on May 19, 1899.

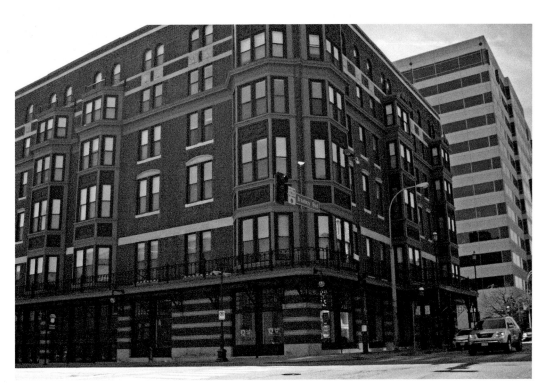

The Coates House was built during Kansas City's most booming decade. Construction on the Coates House began in 1886 and the new hotel was finished over two periods of time, ranging from 1886 to 1891 at the corner of Broadway and 10th street. Kersey Coates died in 1887 during construction, leaving his wife, Sara, and their children to complete the project. On January 10, 1891, the Coates House opened with a gala celebration. The 350-room hotel featured a Turkish bath, billiard room, and heated pool. The hotel featured mahogany woodwork and stained glass throughout. President Grover Cleveland and his young wife spent part of their honeymoon in a suite in October 1887. During the 1940s and 1950s, the Coates House had a convenience store in the first-floor lobby, which was a front for mob activity. By the 1960s, the hotel had fallen on hard times. On January 28, 1978, the south wing was reduced to a heap of rubble. What remained of the Coates House was converted to luxury apartments in the 1980s.

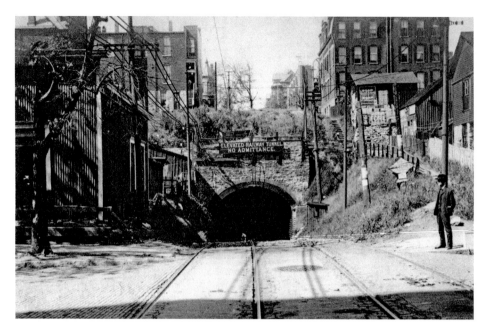

In 1903, a new tunnel was built to remedy the situation of maintenance costs of the cable used to link the West Bottoms with the rest of the city. The new tunnel bore directly beneath the first tunnel, only this time the grade was not as steep. The Metropolitan Street Railway Company used the same west portal as the 1888 tunnel; however, a new east portal was built. The original tunnel east portal was approximately two blocks west at 8th and Washington Street. The original tunnel was plugged. The new tunnel was in constant use from 1904 until 1956. In 1956, the new tunnel was abandoned and its portals were sealed and the entry stations filled in. Both tunnels were forgotten until the 1990s, when a group of engineers found a buried doorway near 8th and Washington Street that was part of the original 1888 tunnel.

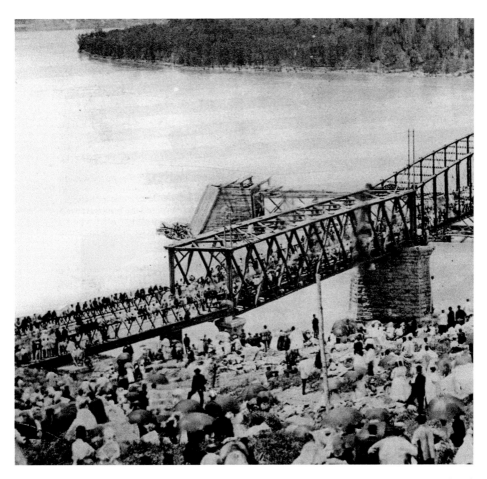

A large crowd gathers to see the newly constructed Hannibal Bridge. Construction was completed in 1869, just after the end of the Civil War. It was a truss design and had an arch. It was built for the Hannibal & St. Joseph railroad by Keystone Bridge Company. It was a swing bridge and could open in under two minutes, and had a cost of $1 million. In 1889, the bridge was damaged by a tornado, which collapsed the middle span. It was reconstructed and its truss structure altered from an arch design to a traditional truss design. It was later replaced by a new Hannibal Bridge, which was built 200 feet upstream. The first bridge was heralded as a modern marvel, allowing cattle and passengers to be shipped around the country by rail without having to disembark a train and cross the river by ferry only to board another train.

OPPOSITE PAGE:

Below: This building sits on the original site of the trolley tunnel. The second tunnel was rediscovered when DST Systems was building on the land above the tunnel, and they occasionally ran tours through the tunnel. The tunnel, which is over 100 years old, is starting to deteriorate, making it difficult to continue running tours through it for safety reasons

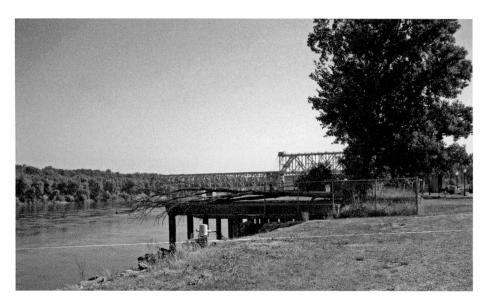

This is what remains of a landing for ferries and barges that once carried passengers and dry goods to and from the Town of Kansas, which eventually grew to become Kansas City. The ASB Bridge can be seen in the background. The history of the bridge is on information panels that were constructed out of the foundation of the former Missouri Pacific Produce Terminal Administration Building, located along the Berkley Riverfront Park Trail.

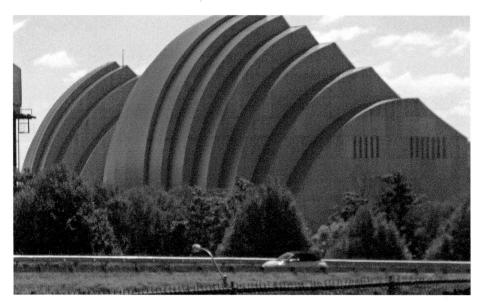

Muriel McBrien Kauffman shared her vision for a performing arts center in Kansas City with her family and friends. Following her death, her daughter began to put her vision into action. The center sits on 18.5 acres and was designed by Moshe Safdie. The twin symmetrical shells house independent performance venues. The total cost of the project was $413 million and was all privately funded. Notable performers have been Willie Nelson, Aretha Franklin, Yo-Yo Ma, Mavis Staples, and Lily Tomlin. The Kauffman Center for Performing Arts has been a boost to the city's revitalization of downtown.

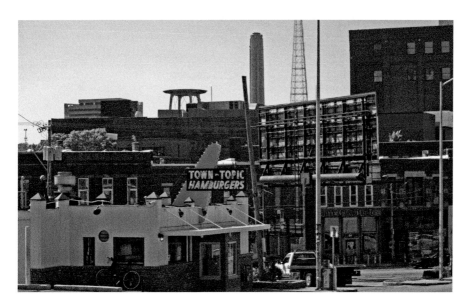

Town Topic Hamburgers building was originally a White Castle, as evidenced by the turrets on the roof, until Claude Sparks opened Town Topic in 1937. After his first day of selling hamburgers for 5 cents, he made $21. The iconic neon sign was built by Noel Barnes patron and friend of Mr. Sparks. Mr. Barnes worked for the Southwest Boulevard Company Signs as a builder and hanger. Mr. Sparks had six locations around Kansas City at one time. The original site is this one at 24th and Broadway.

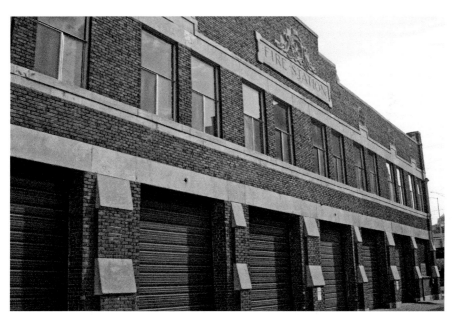

This former Kansas City Fire Station is located on the northwest corner of 14th Street and Liberty Street in the West Bottoms. There had been several fire houses in the West Bottoms since the early 1800s. This was the final fire station to be built in the West Bottoms and was closed sometime in the 1970s. The fire house has been repurposed into commercial space. There was once even a police station located at 1312–1314 Union Street in the West Bottoms.

The West Bottoms was relevant to the economy of Kansas City from the early 1800s up until the early 1970s, when many manufacturing jobs in the United States began to be sent overseas. By the early 1980s, most of the companies in the West Bottoms had moved out of the area or closed their doors forever. Many of the former companies' signage can still be seen on the sides of buildings as evident in this picture.

Opposite page:

Above: Many of the former buildings that once housed furniture companies, equipment manufacturers, and even a casket maker have found new life as antique stores and upscale event space. This has brought renewed interest in the West Bottoms area.

Below: In this photo, it is clear to see how a former warehouse building was able to repurpose its loading dock area into new office space. This is the kind of rehabilitation that is under way in the West Bottoms.

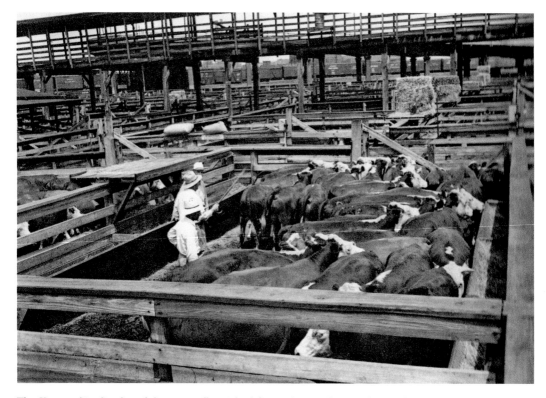

The Kansas City Stockyard Company flourished from 1871 until 1991. The stockyards were built to provide better prices for livestock owners. Prior to the creation of the stockyard, livestock owners were at the mercy of the railroad companies. The stockyards were originally built on the Kansas side of the Kansas River on 13 acres, along the Pacific and Missouri rail lines. In 1878, the stockyard expanded into Missouri and added loading docks, sheds for hogs and sheep, and developed into one of the largest horse and mule markets in the country. On October 16, 1917, a fire destroyed most of the stockyard buildings, killing cattle and leaving the Kansas City Stockyard Company in shambles. The stockyard was quickly rebuilt, and by 1923, 2,631,808 cattle passed through the yard and 1,194,527 were bought for the local meat packing houses—55 percent of the remaining cattle were shipped to other parts of the country. The company was dissolved in the early 1990s and portions of the land were donated or sold off.

OPPOSITE PAGE:

Above: The Kansas City Live Stock Exchange was located at 1600 Gennesse. It was the headquarters of the Kansas City Stockyard Company. Construction of the building began in 1909 and was completed in 1911. At the time of its completion, the building was the largest livestock building in the world. In 1957, a one-story addition was added on the south side of the building. This addition was for the expansion of the Golden Ox restaurant, which had opened in the building in 1949. Today, the building has been completely renovated and serves as an office building for numerous businesses.

Right: The Golden Ox restaurant was the premier steakhouse in Kansas City for over sixty-five years. The interior had dark wood paneling and golden ox heads on the wall with plush booths for diners. In 2014, however, it was announced that the restaurant would be closing its doors. The restaurant reopened two years later in the same location only in a smaller scale thanks to the efforts of Wes Gartner and Jill Meyers, who own another restaurant, Voltaire, across the street from the Golden Ox.

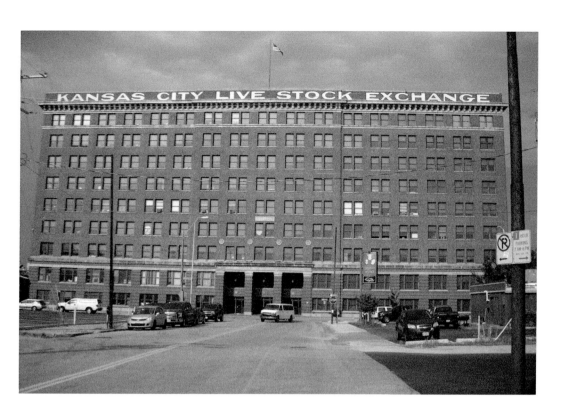

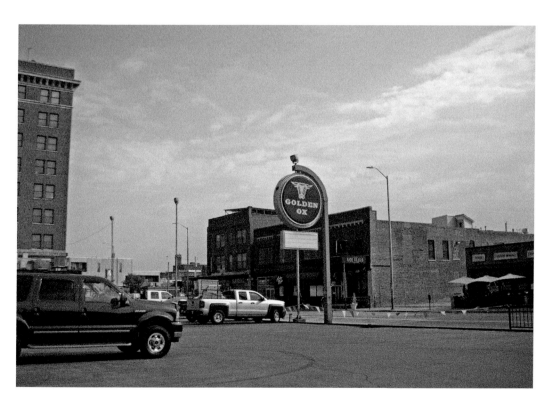

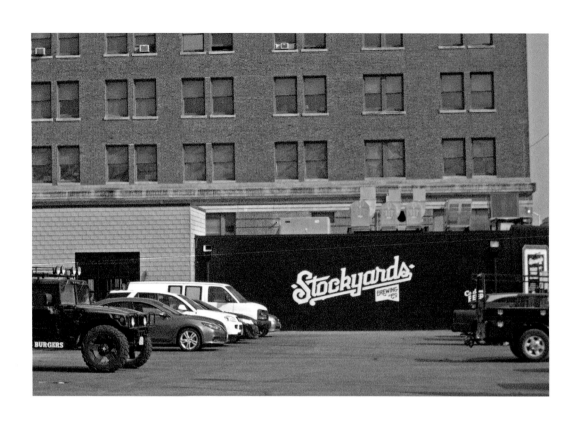

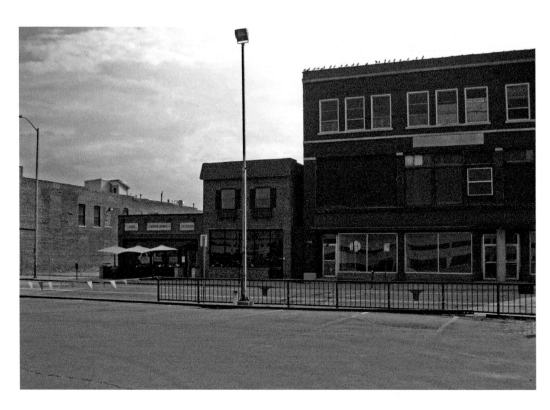

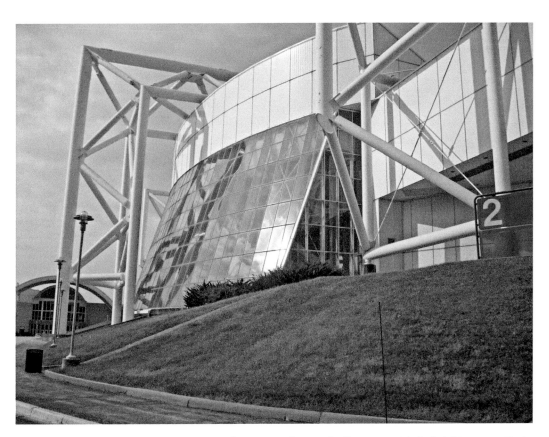

The Kemper Arena is a 19,500-seat indoor arena that was built over a period of eighteen months in 1973 at a cost of $22 million. The arena occupies a portion of the former Kansas City Stockyards and was designed by famed German architect Helmut Jahn. It has hosted the NCAA final four basketball games, 1976 Republican National Convention, American Royale, many concerts (including Elvis Presley), and the WWE pay-per-view Over the Edge, where wrestler Owen Hart fell to his death. It was also home the NBA basketball team the Kansas City Kings and the NHL hockey team the Kansas City Scouts. In 1979, the arena experienced a partial roof collapse due to strong winds and poor roof drainage. Luckily, the arena was closed at the time and no one was injured. The problems were addressed and the arena reopened a year later. The arena is currently being repurposed by the city.

OPPOSITE PAGE:

Above: After the Golden Ox closed, a portion of the restaurant was leased to Stockyards Brewing Company. The new business took over the bar and back dining area of the Golden Ox and an addition was added for storage. The Stockyard Brewing Company has helped to bring brewing back to Kansas City.

Below: The buildings across the street from the Kansas City Livestock exchange have been transformed into bistros and specialty restaurants, all the while retaining the area's quaint 1880s charm.

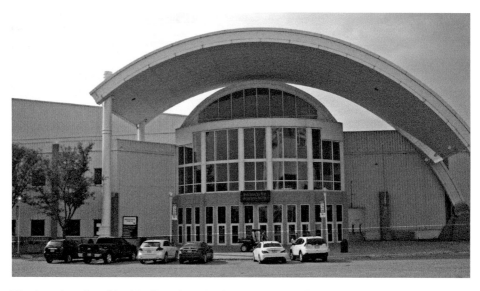

The American Royal had its first show in 1899 in a tent in the Kansas City Stockyards. It has grown from a five-day Hereford Cattle Show to a sixteen-day event that has approximately 6,920 entries and a budget of $400,000 in premiums. A permanent building was built in 1922 at a cost of $650,000. After a devastating fire in 1925, the building was rebuilt. During World War II, the building was used as a glider manufacturing plant and the Royal moved to the pens of the stockyard. A dairy show and rodeo were added in 1949.

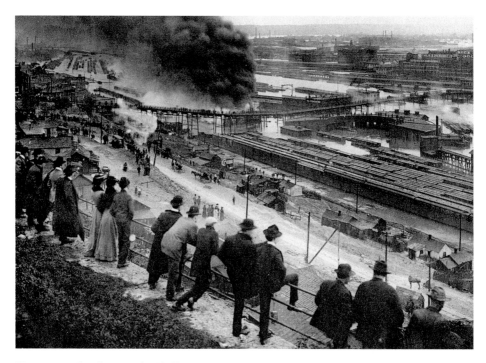

Here, a crowd gathers on the Bluff in 1903 to watch the rising flood waters and sporadic fires on the West Bottoms. This is still the best view of the West Bottoms anywhere in the city. Notice the shanties on the cliffs.

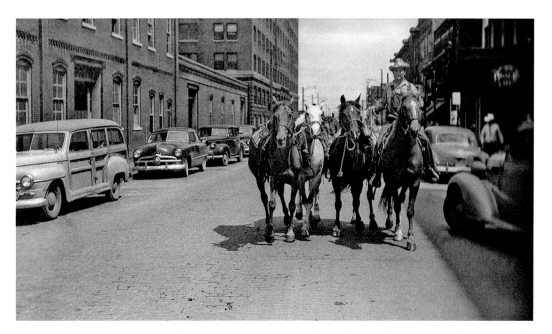

In 1951, flooding began in May with the flood of the Big River. The flooding continued into June, with more heavy rains between June 9 and July 13. Here we see a cowboy taking these horses to higher ground in preparation for what was coming—they are heading south along Genesee Street.

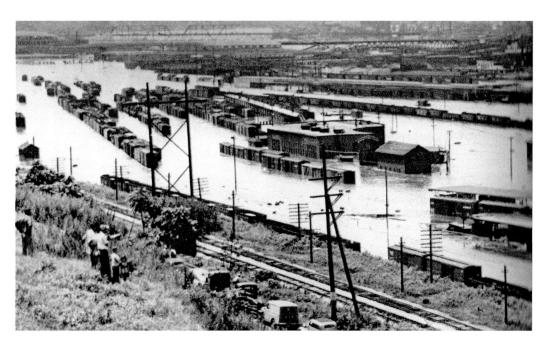

Here is another view of the West Bottoms from the Bluff. Notice the automobiles parked along Kersey Coates Drive and the spectators standing watching the destruction of the railyards and their cargo. The flood even destroyed the TWA overhaul base at Kansas City Municipal Airport. In total, the flood caused over $1 billion in damages—nearly $9 billion today. The 1951 flood almost completely vacated the West Bottoms, and the Kansas City Stockyards never fully recovered.

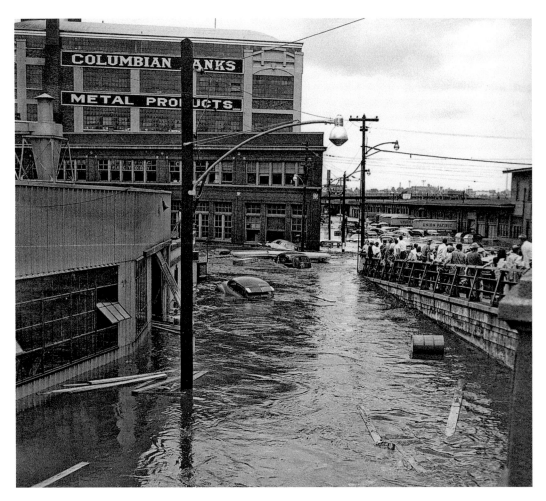

By the time the waters reached Kansas City, they quickly overran the levees and completely devastated the businesses in the West Bottoms. In this photograph, you cannot even see the street or the automobiles. Notice the crowd gathered on the 12th Street Viaduct to view the damage.

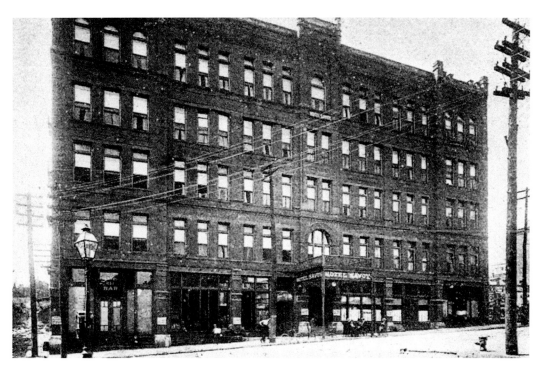

The Savoy Hotel was built in 1888 by the owners of the Arbuckle Coffee Company. In 1903, the original hotel was remodeled and the west wing was added. The new west wing featured the Savoy Grill dining room. In the 1900s, the Savoy was the luxury destination for travelers arriving by train. During Prohibition, the penthouse in the Savoy was converted to a speakeasy. At first, the Savoy Grill only served men, but after a few years, the policy was changed. In 1985, the hotel was carefully restored and turned into a bed and breakfast. The hotel has art nouveau stained-glass windows and hand-laid Italian tile. Originally, there was a roof garden as well. The Savoy Grill was one of six dining rooms on the first floor of the hotel. The hotel was the oldest continuously operating hotel in the United States west of the Mississippi River until it was shuttered due to a kitchen fire in 2014.

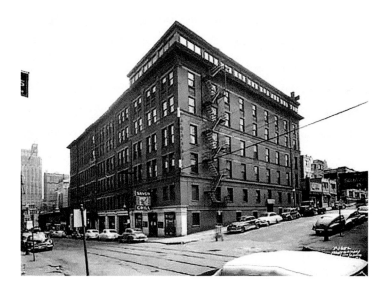

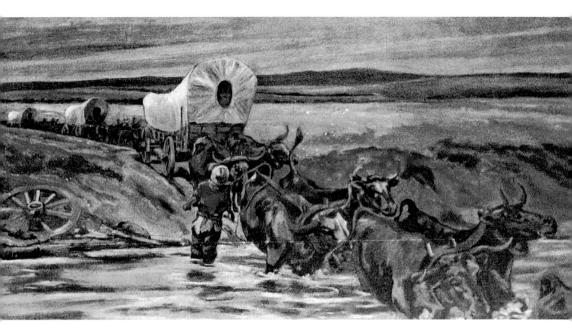

The Savoy Grill still includes the original oak-carved bar and murals painted in 1903 by Edward Holsag. The murals depict the pioneer's departure from Westport Landing and their journey along the Santa Fe Trail. The murals have been included in the Smithsonian's Bicentennial Inventory of American Paintings. Over the years, many celebrities visited the Savoy Grill, including Teddy Roosevelt, William Howard Taft, Marie Dressler, W. C. Fields, Will Rogers, John D. Rockefeller, and Harry and Bess Truman, who always sat at booth four, which is still there. The hotel and restaurant are allegedly haunted. On October 23, 2014, a fire destroyed the kitchen of the Savoy, bringing the restaurant and hotel to an end. The building has been sold and plans are under way to convert the 200-room hotel to a 120-room boutique hotel and restaurant, along with a contemporary art museum.

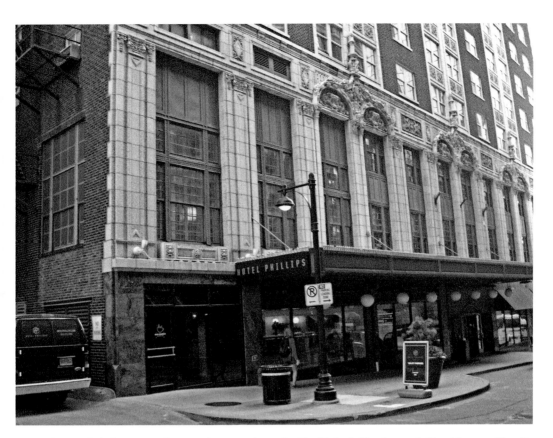

The Hotel Phillips opened across the street from the Muehlebach Hotel on 12th Street in 1931. The site was formerly occupied by the Glennon Hotel, which was where President Harry Truman operated his haberdashery shop after World War I. The 450-room hotel was the tallest in Kansas City when built, topping off at twenty floors. The hotel cost $1.6 million to build and opened in February 1931. The lobby features an 11-foot sculpture of the Goddess of Dawn, created in 1931 by Kansas City sculptor Jorgen Dreyer. The Hilton Corporation purchased the hotel in 2015 and has since fully restored the hotel back to its original luster.

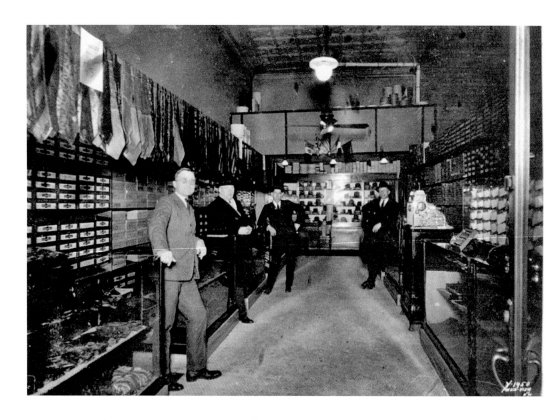

Future President Harry Truman and his friend Eddie Jacobson opened their haberdashery shop on November 28, 1919. They rented their 18 × 48-foot store on the ground floor of the newly renovated Glennon Hotel for $350 a month rent. The business began to fail after about three years, and they finally had a going-out-of-business sale in September 1922. Eddie Jacobson declared bankruptcy in 1925, while Truman struggled paying off his share of the debts, with the last debt being paid in 1935. The location of the shop was 104 West 12th Street near Baltimore Avenue.

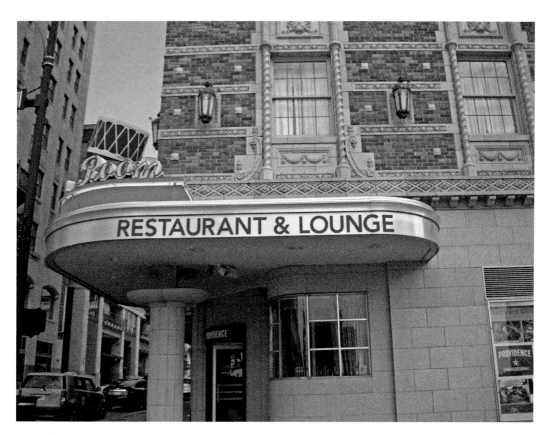

The President Hotel was built and completed in 1926. This grand hotel took two years to complete and featured 453 guestrooms. The hotel was also the first hotel in Kansas City to make its own ice. In 1928, the hotel served as the headquarters for the Republic National Convention, which nominated Herbert Hoover. In 1941, a restaurant and lounge opened in the hotel called the Drum Room. It eventually became a legendary venue in its heyday, with artists such as Frank Sinatra, Benny Goodman, Tommy Dorsey, and Glenn Miller playing there. The hotel closed its doors in 1980 and underwent a $45.4-million renovation project before reopening twenty-six years later. The hotel increased room size and decreased its guestrooms to 213. The hotel has hosted Charles Lindbergh, Marx Brothers, Presidents Hoover, Truman, Eisenhower, and Nixon, as well as Bob Dylan.

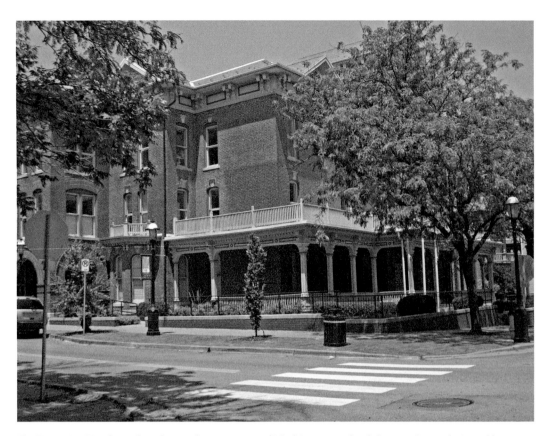

The Virginian Hotel stood on the northwest corner of Washington and 11th Streets. It was designed by Kansas City architects Louis Curtiss and Frederick Gunn. They actually connected and expanded two 1870s homes that were located on the site. Early managers of the hotel were sisters Emma and Ella Garnett, who oversaw a dining room that was popular among the city's elite and prominent families. It operated as a hotel into the 1970s, but stood vacant until the early 1990s. The structure has since been redeveloped and is now the headquarters of Heart of America United Way.

The Cordova Hotel was built in 1899 and the architect was Frank Resch. The hotel was an elaborate five-story brick and cut stone building. The hotel is located on the southeast corner of 12th and Pennsylvania Streets. The building was saved from the wrecking ball and has since been restored to its former glory. The Cordova has been turned into apartments and remains an architectural treasure of Quality Hill.

At the corner of Broadway and West 8th Street is the Phoenix Hotel Building. It was built in 1888 and housed a saloon on the first floor, which was owned by bartender Frank Valerius. Rowdy crowds of laborers would frequent the saloon after their shifts were over in the garment district. The hotel was located on the second floor and was owned and operated by Mrs. Linna Laws. The hotel was rumored to be more of a brothel than a hotel. Today, the building has found a new life as The Phoenix a jazz club and restaurant.

The Exchange Hotel was located across the street from the Phoenix on West 8th Street. The building was built in 1889 and operated as a hotel for a while before going out of business. Today, the building houses the Henry J. Epstein Company. The company is a small wholesale tool store that was started mid-century. The company is run today by the great grandson of the founder.

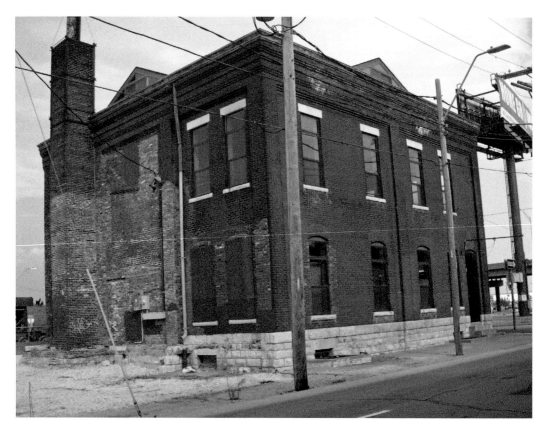

This building, located on the corner of 14th Street and Wyoming in the West Bottoms, was originally a school that was started by Father Bernard Donnelly, who was born in County Cavan, Ireland. He was both a civil engineer and an ordained priest. He worked in civil engineering first in Dublin, Ireland, and then in Liverpool, England, before coming to the United States in 1839. He first taught at Ohio State University and then at St. Mary's Seminary. He was ordained in Saint Louis, Missouri, in 1845. He was sent to Independence to pastor, and then, in 1857, he was appointed resident pastor in the Town of Kansas, later renamed Kansas City, in Missouri. He aided 300 Connaught immigrants to the city for the Bluff work in helping to grade the streets. He also helped build the Cathedral of the Immaculate Conception from the ground up, as well as Saint Teresa's Academy, two orphanages, St. Mary's Cemetery, and St. Joseph Hospital

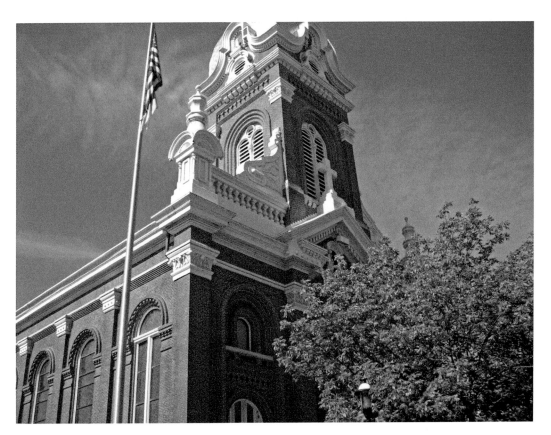

The Reverend Benedict Roux arrived in Kansas City in 1833; two years later, he built a church out of logs at 11th and Broadway. Between 1845 and 1880, the parish was served by Reverend Bernard Donnelly. He had a brick church built in 1857, and he named the parish Immaculate Conception. The Diocese of Kansas City was established in 1880 and the Immaculate Conception was chosen as the Cathedral for the new Diocese. The Cathedral was built on the highest ground of the city and had a 250-foot spire, making it the tallest building in the city at the time. A carillon of eleven bells was placed in the tower in 1895. Each bell is named after a different saint. The stained-glass windows were made from local artisans at the Kansas City Stained Glass Works Company and were installed in 1912. They depict various bible scenes and the life of Christ. The first mass had over 3,000 in attendance and lasted four hours. In 1956, the Diocese merged with the Diocese of Saint Joseph, thereby creating co-cathedrals for the Diocese.

The Christian Brothers who arrived in 1889 ran a boy's school, which was connected with Cathedral known as the Cathedral Commercial School. The school was run out of the church basement until a building could be completed. The building was in constant use until a new school building was built in 1953. The new school building was attached to the parish gymnasium that was constructed in 1943 on Broadway between 11th and 12th Streets. A new rectory was built on the site of the old school house. On May 24, 1966, it was decided to close Cathedral School. This decision came about due to low enrollment and the school having two grades in each classroom. The remaining students at Cathedral were consolidated with the students at Our Lady of Guadalupe and Sacred Heart Parrish into a new school called Our Lady of the Americas. In 1974, the school building and gymnasium were remodeled to become the Center for the Diocesan Department of Catholic Lay Activities.

OPPOSITE PAGE:

Saint Paul's Parish was established on Quality Hill on July 20, 1870. It was renamed Grace Church on April 14, 1873. The present church is the second church to be built on the site, and the first to be built out of stone. The present structure was designed by Frederick Elmer Hill. The first stone structure on West 13th Street, now known as Guild Hall, was constructed in May 1888 through to March 1890. Construction of the present Nave began in June 1893. The style of the building is transitional Norman Gothic. The interior of the Nave was completed in December 1894. The first worship service was held on December 16, 1894. The oak pews in the Nave are original to the structure and can seat up to 800 parishioners. The stained-glass windows are some of the most beautiful in the United States. In November 1917, the parish merged with Trinity Church, which had been established in 1883. On October 29, 1935, the parish became a Cathedral of the Diocese. Today, the church continues to grow and thrive on the West Side.

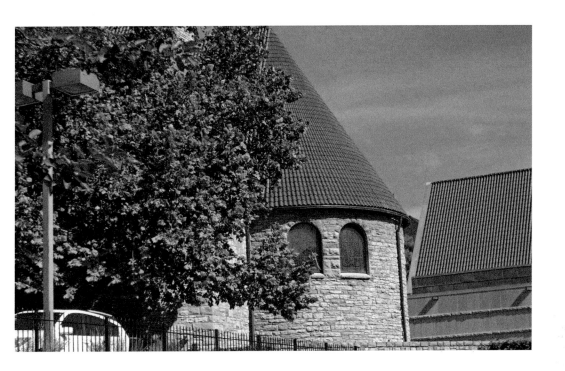

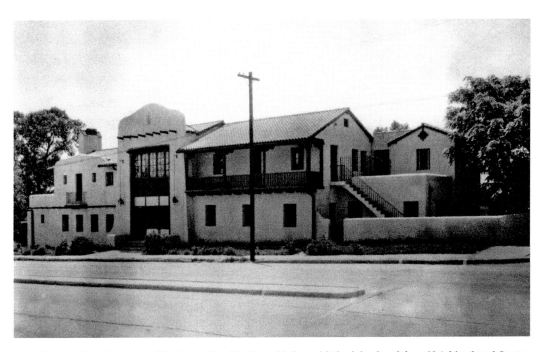

In 1919, the volunteers of the Agnes Ward Amberg Club established the Guadalupe Neighborhood Center to take on the needs of the newly settled Hispanic Community. In 1936, a new building was completed at a cost of $21,000 at 1015 West 23rd Street, now known as Avenida de Cesar Chavez. The center provided healthcare, childcare, translation services, English classes, legal advocacy, and job placement. The building and the organization still provide services and remain a strong ethnic social organization in the community.

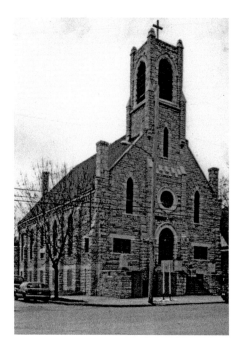

Our Lady of Guadalupe Catholic Church was formally consecrated on October 5, 1919. Each person attending the service brought a candle, as was the Mexican custom. In 1990, Our Lady of Guadalupe Church was consolidated with Sacred Heart of Jesus Parish. The church was closed and now awaits a new life possibly as a museum.

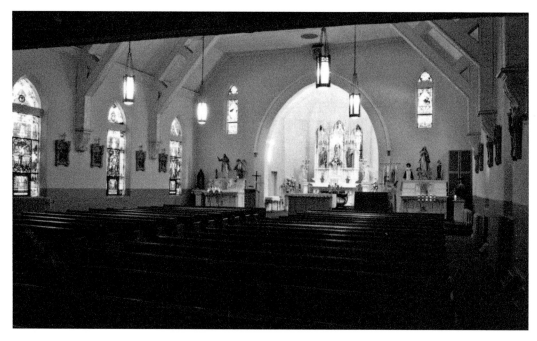

This is an interior view of Our Lady of Guadalupe Church. The Redemptorist Fathers donated the main altar, the Knights of Columbus donated the carpet for the church, and other parishes contributed as well. Many of the parishioners were of meager means, but they too pledged money to pay off the debt incurred by building a church, even though it meant a great financial sacrifice. Originally, the church had been a Swedish Evangelical Lutheran Emmanuel Church. The property was hardly changed except for the removal of a stained glass window of Martin Luther. The church could hold 400 attendees although it has been cited at 900 attendees.

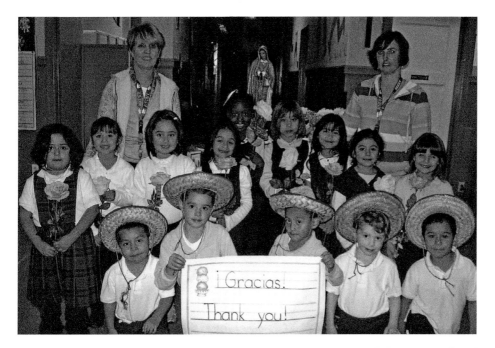

Our Lady of Guadalupe School can trace its origins back to 1919 when small classes were offered in the basement of the church. In 1927, a new building was dedicated in August. The new building was designed by architect Henry W. Brinkman of Emporia Kansas. The building was two stories with classrooms and offices for the Sisters who staffed the school. On the second floor, there was an open-air room, which was staffed by a nurse and doctor for children with TB and Polio. The room was discontinued in 1942. The school has since been closed and consolidated with another Catholic School. Here we see one of the last classes before the school closed.

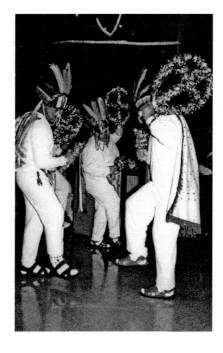

Members of the Mexican Dance Group Los Guadalupanos performing during the Diocesan Celebration of Our Lady of Guadalupe at the Cathedral of the Immaculate Conception Church. Entertainment such as this dance group also perform at the fiesta as well. The dancers make a concerted effort to preserve the dances and music from the states and cities their ancestors left in Mexico when they came to Kansas City.

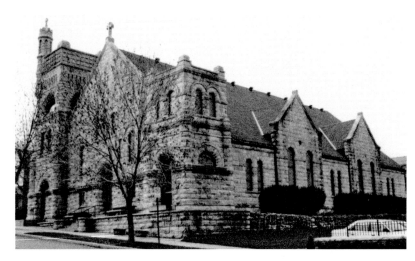

Sacred Heart of Jesus Parish Church was built between 1887 and 1897, when the church edifice was completed. The parish was originally made up of Irish immigrants and the edifice of the church reflects it, similar to stone churches you would find in Ireland. The parish school was the oldest continually operated parochial school in Kansas City before it closed. From 1958 to 1964, the school was closed due to low enrollment and classes were held at Saint Joseph Orphan Boys Home at 31st Street and Southwest Trafficway. The parish was decimated by the highway system in the early 1960s. In 1990, the Diocese decided to consolidated Sacred Heart and Our Lady of Guadalupe parishes. The new parish would be located at Sacred Heart and be called "Sacred Heart Guadalupe." The school was closed as well and is used as a day care facility.

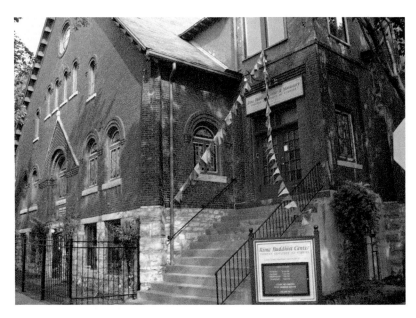

This is a full exterior view of the Disciples of Christ West Side Christian Church. It was located at 708 West Pennway on the northeast corner of Jefferson. The inset is a picture of Pastor Andrew B. Blue. The building was built in 1900. The Rime Buddhist Center now occupies the building.

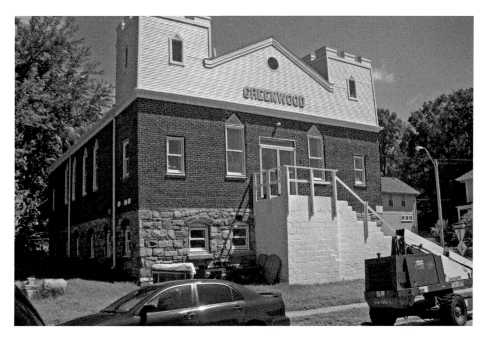

The Greenwood Baptist Church is located at 1750 Belleview Avenue. It was designed by African-American architect Waverly Thomas, which makes the building unique as the only one on the West Side that he did. The building has been used for church services, concerts, and plays.

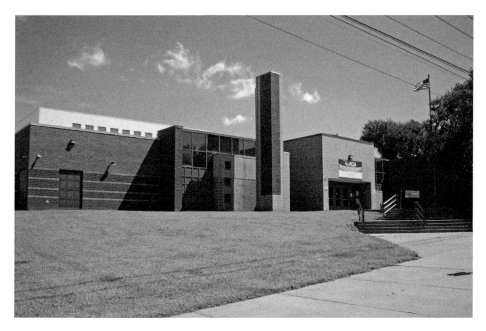

Primitivo Garcia Elementary School is located on West 17th Street. The school serves 380 students from preschool through sixth grade. The school is named after a Mexican-American student, Primitivo Garcia, who was fatally wounded by a gunshot in 1967 when he and his brother were trying to protect their pregnant English teacher from being robbed. The Garcia family is still very active in the community and the school continues to preserve and honor Primitivo Garcia's memory.

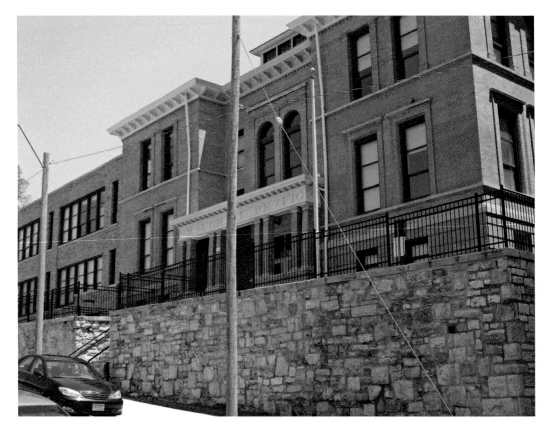

The Switzer School opened in 1881 and served as a middle school. Educators believed that children would not go to high school so Switzer offered classes from seventh through tenth grades. The 82,596-square-foot complex is made up of five buildings that were built at different times. Switzer North was built in 1882 and had grades five through seven. It had a one-story wood frame annex built in 1885. The school was heated originally by two wood stoves. The annex was razed in 1939. Switzer South was a two-and-a-half-story Italian Renaissance Revival built in 1899. The building had eight rooms and was the first school to have electric lights and offered night classes. The elementary school also was the first school in America to offer a girls club in connection with the YMCA in 1912.

Opposite page:

Above: West Side Junior High was built in 1925. This classically inspired building offered community spaces, gym, classrooms, and a branch library. An addition was built in 1939, connecting the Junior High to the Switzer complex using WPA funds. The addition replaced the elementary school. Another addition was built in 1958, allowing the Junior High to offer industrial arts classes. A third story was added to the annex in 1962. The entire complex closed in the 1980s and sat abandoned for over thirty years. Today, the complex has been completely renovated and converted into 114 affordable luxury apartments.

Below: This is a view of the newly renovated West Junior High Industrial Arts building. The addition was built in 1950 and housed shop classes for students. A third floor was added in 1962. Today, the building has been restored to its former glory and is a wonderful addition to the apartments.

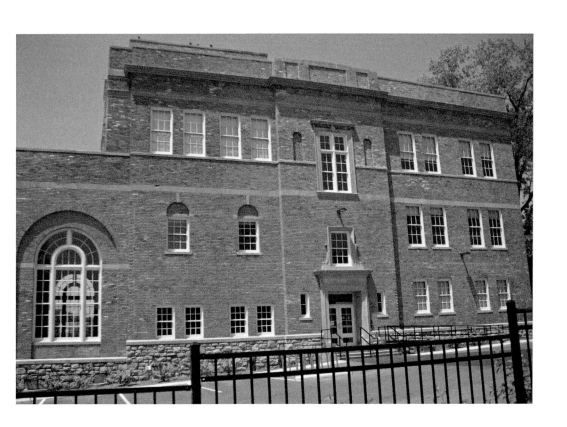

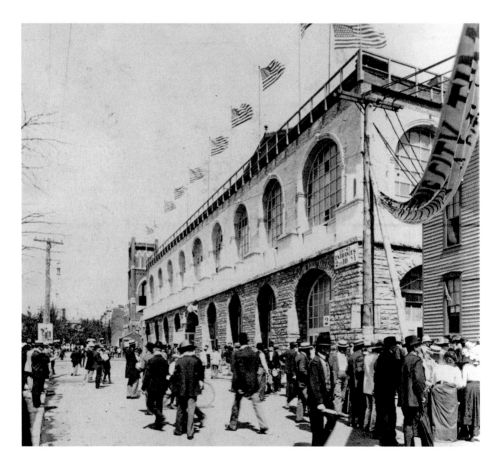

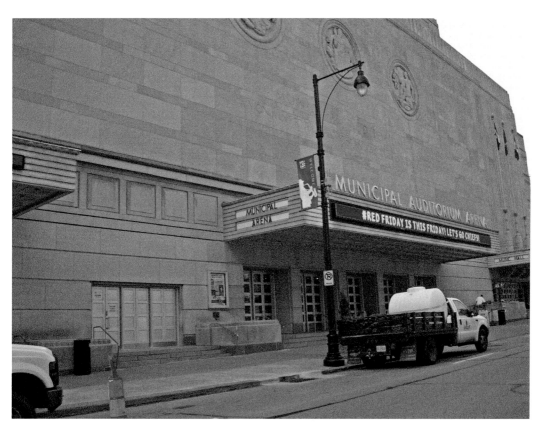

301 West 13th Street is the location of Municipal Auditorium. It was the first building built as part of a ten-year bond program that was passed in 1931. The plan was championed by politician Tom Prendergast. The building was designed by the architectural firm Gentry, Voskamp & Neville. The building was to replace the aging Convention Hall and opened in 1935. That same year, the Architectural Record called it one of the ten best buildings in the world that year. The building boasts an arena, music hall, little theater, and ballroom. The building is connected to the H. Roe Bartle Convention Center. In 2013, the building underwent a $5-million renovation to restore the building to its original luster.

OPPOSITE PAGE:

Above: The River Club on Quality Hill was organized in 1948. The Clubhouse was completed in 1950. It was partially burned when a fire broke out in December 1954. The building was rebuilt and redecorated in four months. The main dining room is decorated with many oil paintings of riverboat scenes by Anthony Benton Gude, grandson of Thomas Hart Benton. Over the fireplace is a Thomas Hart Benton masterpiece as well. Since the club was founded, it has hosted presidents, dignitaries, and world-famous performers.

Below: Convention Hall was designed by Frederick E. Hill and built at the corner of 13th and Central Streets at a cost of $225,000. The hall opened on February 22, 1899. On April 4, 1900, the hall was completely destroyed by fire. Frederick E. Hill designed a new fireproof building and it was rebuilt in ninety days in order to still host the Democratic National Convention. The Hall also hosted the 1928 Republican Convention. The most controversial use of the hall came in 1922 through 1924 when it hosted the Ku Klux Klan rallies. The building was torn down in 1936, and the site became a parking lot for Municipal Auditorium.

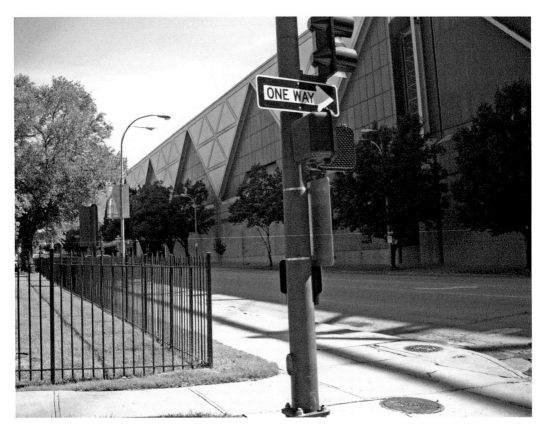

H. Roe Bartle Hall opened in 1976 and was named after Mayor H. Roe Bartle, who was mayor of Kansas City during the 1950s and early 1960s. In 1994, the expansion of the hall was completed at a cost of $91.7 million. The Kansas City skyline was changed forever with the construction of four steel columnar structures built to support steel cables that suspend Bartle Hall Convention above Truman Road and Interstate 670. Each column is 335 feet high and topped by four sculptures that were designed by artist R. M. Fischer. The sculptures are made of aluminum and steel and are called sky stations. They were placed atop each pillar by helicopter. After the expansion, the convention hall has 338,000 square feet of column-free exhibit space. When the expansion was begun, several businesses were forced to close down due to the land being taken to make room for the expanded hall. One of them was the Auditorium Bar and Grill located at 217 West 14th Street; it had been in business since 1942.

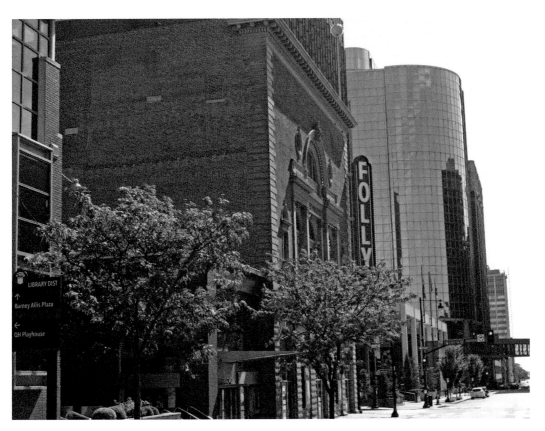

The Folly Theater was built in 1900 and designed by Kansas City Architect Louis S. Curtiss. The theater was originally named the Standard Theater and was associated with the adjoining Edward Hotel, later known as the Hotel Missouri, which was also designed by Curtiss. The hotel was razed in 1965. It was built by Colonel Edward Butler of St. Louis, Missouri, at a cost of $250,000 for his son to present shows on the Empire Vaudeville Circuit. When the theater opened, it had 2,400 seats and a manager's apartment. A prize fight took place at the theater between Jack Johnson and Jack Dempsey at the theater. The Marx Brothers performed here in 1923. In 1941, the theater was renamed the Folly and featured striptease—performers included Gypsy Rose Lee and Tempest Storm. In 1969, the theater began showing adult movies. The theater closed in 1974. A local historic preservation group began raising money to purchase the theater. In 1981, restoration of the theater was finally completed. The ball on the pole on top of the theater is dropped each New Year's Eve in Kansas City's version of the Times Square Ball.

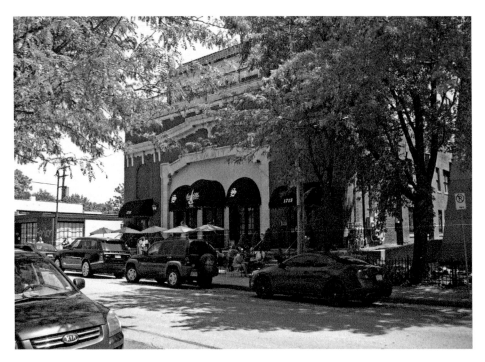

The Summit Theater was located on Summit Street near the corner of 17th Street. The theater opened in 1937 and had a seating capacity of 622 seats. In 1941, the Commonwealth Amusement Company operated the theater until it closed its doors for good in 1958. The theater remained abandon for decades until it was converted into apartments. The lobby was repurposed into a café. Every effort was taken to preserve the façade and the original theater ceiling in the apartments.

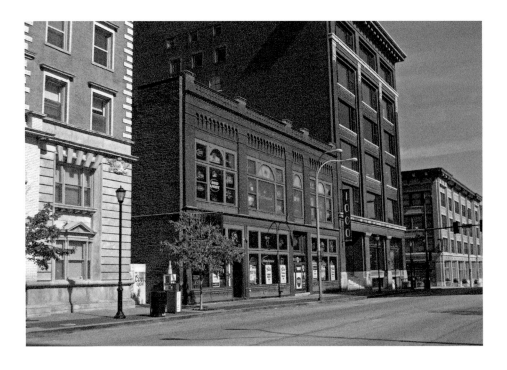

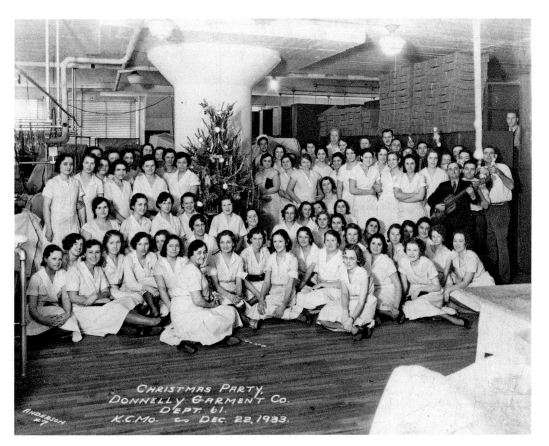

This is a photo of some of the workers of the Donnelly Garment Company having a Christmas Party in 1933. The owner Nell Donnelly Reed was born Ellen Quinlan on March 6, 1889 in Parsons, Kansas. She learned to sew at an early age, and after graduating high school, she moved to Kansas City. She met and married Paul Donnelly, and in 1909, she graduated from Linwood College. In 1916, she began making her own dresses and selling them at George B. Peck Dry Goods Company. Within three years, she established the Donnelly Garment Company, which produced house dresses and aprons. By 1931, the company employed 1,000 workers and had sales of $3.5 million. The Company provided employee pension plan, on site medical clinic, cafeteria, group hospitalization and life insurance benefits, employee recreation center, tuition reimbursement, and a scholarship fund for employee children. By 1953, it was the largest dress manufacturer in the world and was nonunion. In 1956, she sold the company and it was renamed Nell Don. In 1968, the company unionized, and by 1978, the company filed for bankruptcy. She died at the age of 102.

OPPOSITE PAGE:

Above: At the corner of 10th and Broadway is the W. R. Nelson Trust building located at 1000 Broadway. During the 1950s, the businesses occupying the building are as follows. The basement was the location of Ti-Pi Company, the first floor housed Rose Mercantile, the second floor had Lan Mar Manufacturing Company, on the third floor was Jenny Garments Inc., the fourth floor had Herden Morris Inc., fifth floor Danny Dare Boys wear, and the sixth floor had Vic Gene manufacturing. After the manufacturing left the area, the building remained vacant for some time before being rehabbed into office space. The building to the left of the Nelson building houses the Quaff Bar and Grill. The Quaff has become an institution on the West Side as a favorite watering hole among locals.

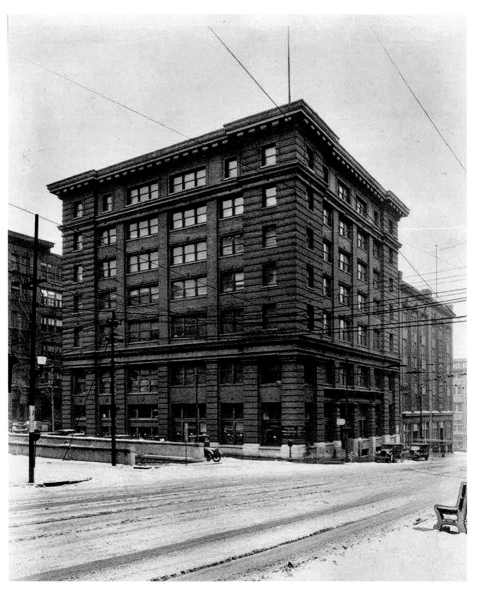

This view of the northwest corner of 8th and Broadway was taken on a snowy day in 1928. The building was occupied by the Gallagher Drug Company. Negbaur & Sons is also in view at 704 Broadway. Walter Negbaur operated a dry goods business for many years on Broadway. To the left of the building is the entrance to the street car tunnel. Notice how the street was not plowed and how few automobiles were on the road.

Opposite page:

Above: The building in the center of the photograph was the Harvey Dutton Dry Goods Company. It was located at 800 Broadway. The building on the right is the Faxon, Horton & Gallagher Company. Its physical address was 712–716 Broadway. This photo was taken at the intersection of Broadway and West 8th Street looking northwest. Both buildings are still there today and have been repurposed into loft apartments.

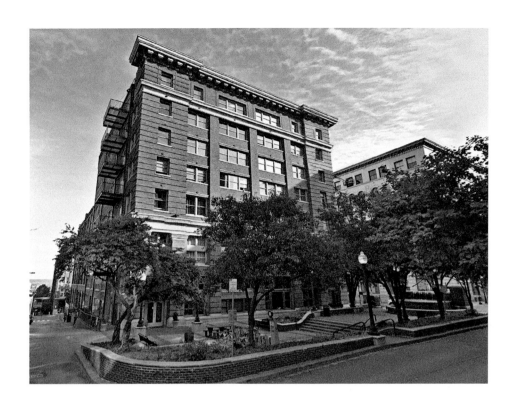

Brackett Brothers Drug Store was located at 935 Broadway. The two-story brick building was later occupied by Seiden Furriers. They were Kansas City's longest operating furrier. The business occupied the sight beginning in the 1930s all the way to 2013, when they officially closed the doors for good. The building remains vacant at present awaiting redevelopment.

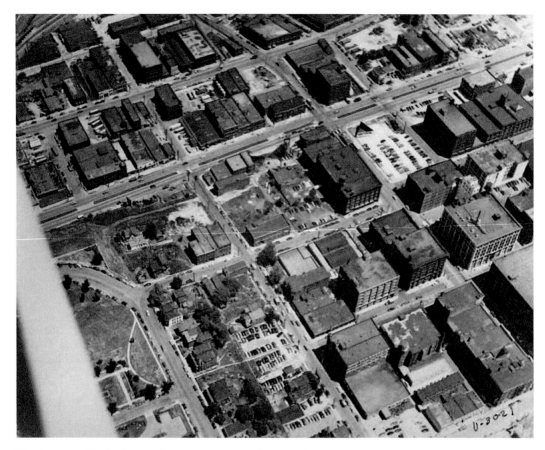

The Garment District began when garment manufacturers began popping up on the upper floors of dry goods companies in the early 1920s. This aerial photograph was taken in 1955, and it is easy to see just how extensive the garment district was during its heyday. One in seven women in the United States purchased a garment designed and made in Kansas City. During this time, approximately 4,000 people were employed in the garment industry, making it the second biggest employer in Kansas City. The Rivergate building, Boese Hilburn building, Design Exchange building, Benchmark building, Thayer building, Frazier building, Ashley building, 930 Central building, Poindexter building, Lucas Place building, 715 May building, and the SoHo West building have all been placed on the National Register of Historic Places. These buildings have all found renewed life as loft apartments or mixed-use commercial and office space.

<small>Opposite page:</small>

Above: Here is an example of a former garment building that has been renovated into a mixed-use space of offices and apartments. This building is located on 8th Street behind the Benchmark building. The Garment District is perhaps the most revitalized area of the city.

Below: Youthcraft Manufacturing Company was located at 306 West 8th Street. They manufactured clothing for women and children, which sold throughout the Midwest. The company occupied the fifth, sixth, and seventh floors of the building. The company went out of business sometime in the early 1990s.

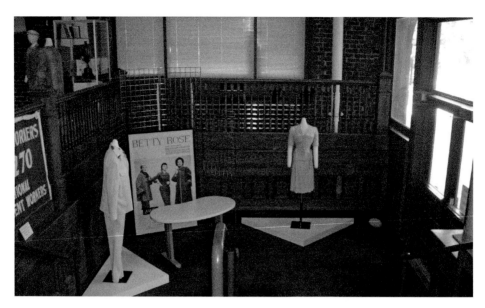

The Historic Garment District Museum is located at 801 Broadway in the heart of the former garment district. The museum was founded in 2002 by Ann Brownfield and Harvey Fried. The Kansas City Museum, which is owned by the Kansas City Parks and Recreation Department, took over the museum in 2015. The museum showcases about twelve companies that made up the garment district. The collection has over 350 garments that were made in Kansas City from 1920 to about 1970, including machinery as well.

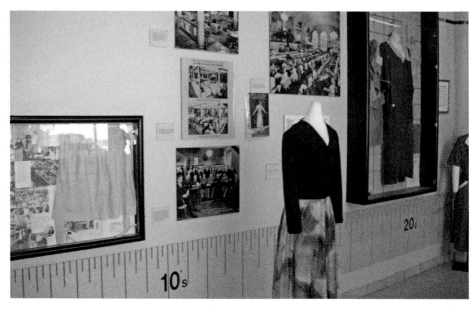

The Historic Garment District Museum has a variety of garments that were made in Kansas City from the early 1920s up to the mid-1960s, when the industry began to decline. As the population began to leave rural areas and move to cities, many of the manufacturers in Kansas City saw dwindling profits, which forced many struggling companies to cut production and lay off workers before inevitably filing bankruptcy by the 1970s.

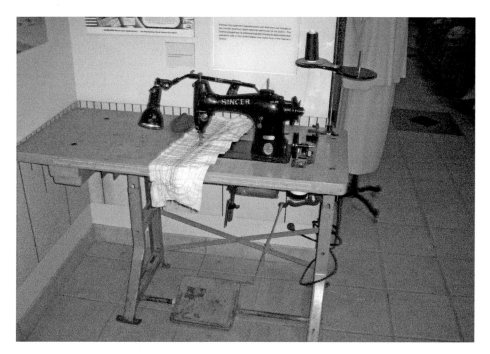

Here is a Singer Sewing machine that is on display in the museum. At some garment companies, there may have been as many as 100 women working on these machines at one time. This machine and work station is from the late 1920s.

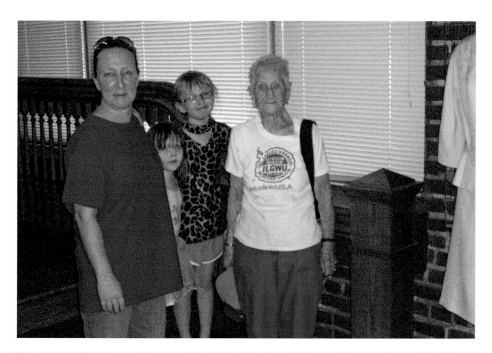

Here is Dorothy Devaney, her granddaughter, Charlene Craig, and her great-granddaughters, Meadow and Danica Craig. Dorothy worked for Maurice, Fashion Built, and Youthcraft companies from the 1940s until the early 1960s, and was a proud member of the Ladies Garment Union.

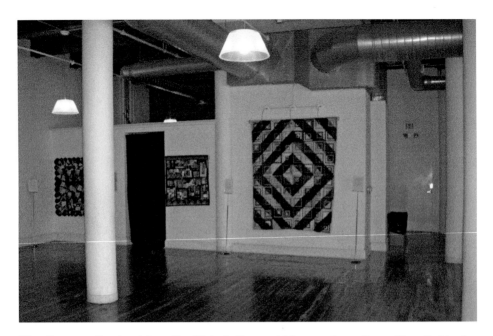

Directly across the street from the Historic Garment Museum is another gallery that is also operated by the Kansas City Museum. They have displays by local Quilt Artists showing a rich history of textiles in Kansas City.

Andrew Drips Park is located at Belleview Avenue and 16th Street. The park is not very big but is one of the oldest parks in the city—it was acquired in 1882. The park does not have any playground or shelters. There is, however, a stone monument commemorating Andrew Drips, an American Fur Company agent. His daughter, Catherine Mulkey, deeded the land to the city. Originally, the park was known as West Prospect Triangle, until it was renamed in 1951 to Andrew Drips Park.

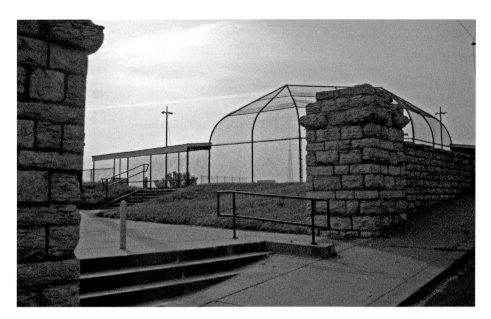

Observation Park was originally known as Gaston Park. The park located at West 20th Street and Holly held a reservoir containing 8 million gallons of water for the West Bottoms. Kansas City Fire Department and Water Commission utilized the modest 4½ acres, while a public park arose next to the reservoir. In 1909, Kansas City Architect Van Brunt erected a bandstand and comfort station. The bandstand was heavily vandalized and rebuilt three times within twenty years and never rebuilt again. In 1953, the reservoir was filled in and replaced with a baseball diamond.

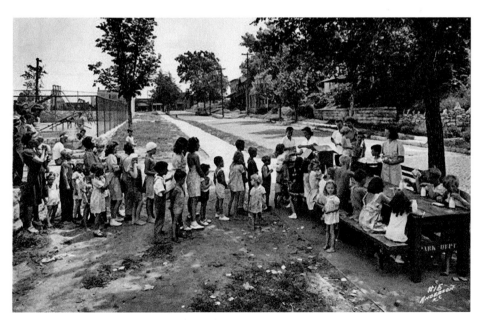

Mulkey Square Park is named after William K. Mulkey the first settler on the West Side. The park originally had a wading pool, which was later removed. In this photograph from 1942, participants line up for the summer feeding program. The park also became home to Bob the bull in 2002. The bull originally resided outside the American Hereford Association Headquarters on Quality Hill.

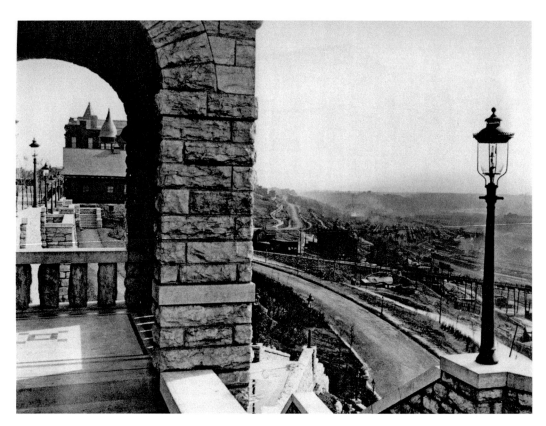

West Terrace Park it is one of the oldest parks in the Kansas City Park System and two other parks Mulkey Square Park and Jarboe Park are included within its 31 acres. Landscape Architect George Kessler drew up a master plan. He envisioned the shanties torn down and cliffs covered in ivy. He wanted lookout points along the park so that the view would be uninterrupted. In the 1950s, a portion of the park and Kersey Coates Drive were condemned to build the Southwest Trafficway and Interstate I-35. The park is the jewel of the park system in Missouri.

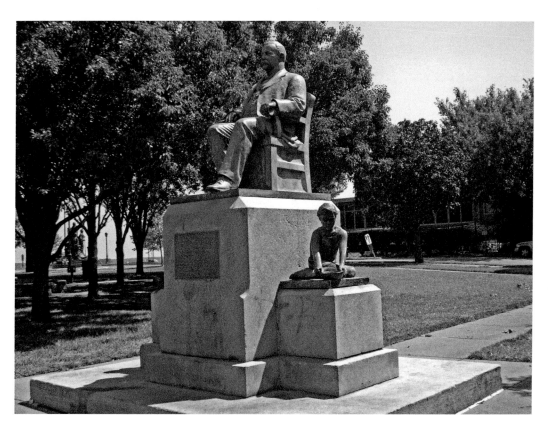

James F. Prendergast was born in 1856 in Gallipolis, Ohio. He was the oldest of nine children. His family moved to Saint Joseph when he was three years old. He moved to Kansas City in 1876 and worked in an iron foundry. In the early 1800s, he took his winnings from a horse race and purchased the Climax Saloon and a small hotel in the West Bottoms. In 1884, he was elected as a delegate to represent the Sixth Ward in the Democratic City Convention. In 1887, he became the Democratic Committeeman from the first ward. He was elected alderman in 1892 and gradually built a personal political organization within the Democratic Party. He served nine terms as alderman on the city council. He died on November 10, 1911. This monument of him was erected in 1913 and paid for with public funds. The statue has been in several locations, including Cliff Drive and Mulkey Park, and was constantly being vandalized over the years. It was finally restored to its original luster and has been permanently placed at West Terrace Park on Quality Hill overlooking the West Bottoms.

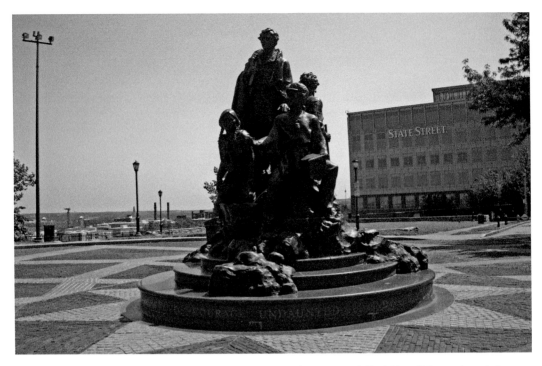

In April 2000, a statue called "Corps of Discovery," honoring the Lewis and Clark Expedition and created by Eugene Daub, was dedicated at West Terrace Park. It depicts Meriwether Lewis, William Clark, Sacagawea their Native American guide, York Clark's African-American servant, and Seaman Lewis' Newfoundland breed dog. This is the only statue depicting an African-American slave in Kansas City.

Here we see West Side resident Jack Devaney posing for a picture near the wall fountain overlooking Kersey Coates Drive. The fountain and the stairs leading up to West Terrace Park were removed when the land was condemned for the highway system. Today, this area is covered with overgrown ivy.

From the 1950s until the mid-1980s, the only housing that was built on the West Side were the Quality Hill Apartments. The homes that were located within this two-block sight were demolished to make way for the apartment buildings. The apartments have a wonderful view of West Terrace Park and the West Bottoms.

New modern apartment buildings are currently under construction at West Terrace Park. These apartments are being built on what had formerly been parking for park goers. Residents of Quality Hill are excited to see more housing being added to the area as Quality Hill goes through a renewed renaissance.

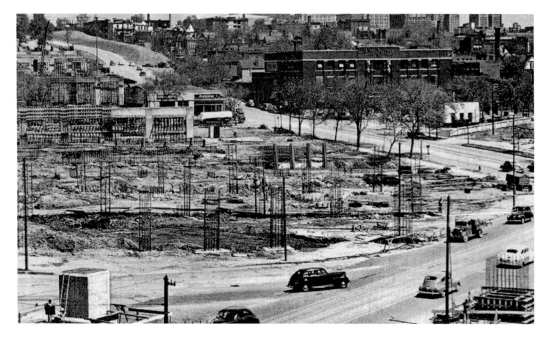

This is a view of the West Side, *circa* 1950. The Southwest Trafficway Viaduct can be seen on the left under construction. It formally opened in November 1950. The Viaduct would begin just north of 26th and Summit and carry cars over the terminal railway tracks and empty onto 10th and Washington Streets.

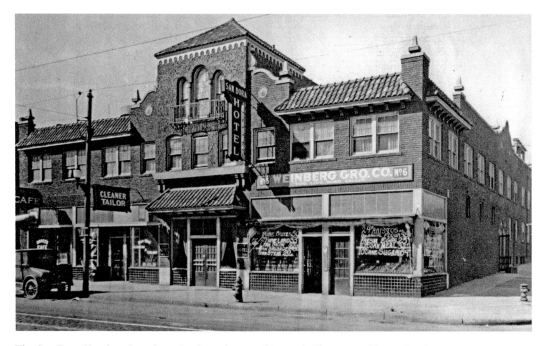

The San Dora Hotel on Broadway Boulevard opened in 1926. They rented lower level street space to Weinberg Groceries, laundromat, and barber shop. The building was located near 15th Street and Broadway Boulevard. The San Dora later was renamed the Stevens Hotel. It was torn down in 1964 to make room for the freeway loop.

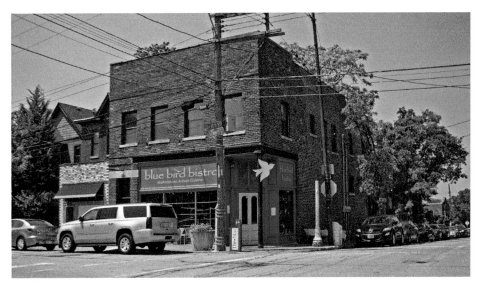

The Blue Bird Bistro on the southwest corner of 17th and Summit is a nice place to have lunch. The building the bistro is housed in has a long and sordid history. It has been used as a drugstore until another drugstore was built across the street and then it became a speakeasy over the years. In the 1950s and 1960s, it was a spiritualistic church. On the second floor, Dr. Bagbee had his medical practice there until the mid-1950s. The building still retains its original tin ceiling and looks very much as it did when it was built.

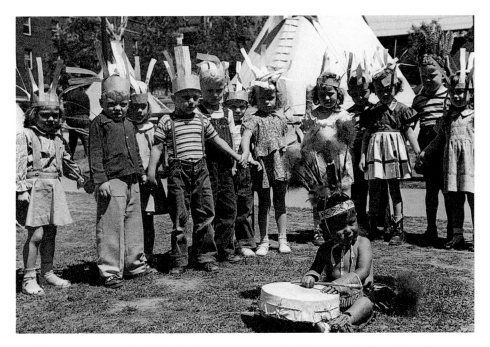

Children from the nearby Salvation Army Nursery visited the Indian Village. The Village was established by the Centennial Planners in 1950 on a vacant lot across from 13th Street and Municipal Auditorium. The vacant lot is now part of the Barney Allis Plaza. The Indian Village was inhabited by actual Native Americans from Oklahoma.

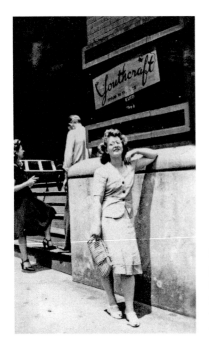

Here we see employees on break outside of the Youthcraft garment building. The company occupied the fifth, sixth, and seventh floors of 306 West 8th street. The company made suits and coats, which were sold in stores from Dallas to New York. The company closed its doors in 1983. Today, the building has been refurbished into loft apartments.

This building was the headquarters for the American Hereford Association, which was founded in 1883. From 1919 to 1953, its headquarters was located at 300 West 11th Street across from the Lyric Theater. On October 16, 1953, President Dwight D. Eisenhower presided over the opening of a new headquarters at 715 Kirk Drive, which included a famous restaurant. The most distinguishing factor was a fiberglass statue of a Hereford Bull, which sat atop a 90-foot pylon. The bull was nicknamed Bob (bull on building) by locals.

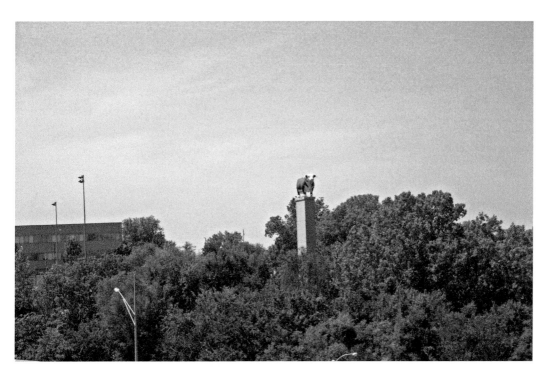

In 1997, the American Hereford Association sold the building to HNTB Architecture Firm and the bull was removed and placed into storage. Many residents missed seeing Bob the bull, and in 2002, the iconic bull was restored and placed atop a pylon in Mulkey Square as a reminder of the great cattle industry that once thrived in Kansas City.

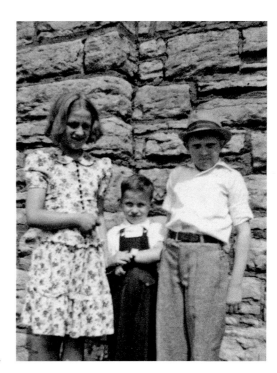

Here we see West Side residents. *From left to right*: Dorothy Ross Devaney, Robert Sonny Ross, and an unknown friend posing for a picture against the stone wall at West Terrace Park. At the time the photo was taken, the park was heavily utilized by the children who lived in the surrounding homes adjacent to the park.

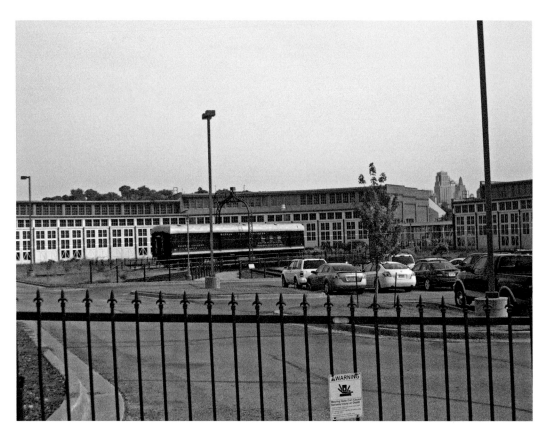

The Kansas City Railway Company had a roundhouse and repair facility located at 27th Street and Southwest Boulevard. The facility was responsible for servicing passenger trains and cleaning them. At the roundhouse facility, crews worked around the clock to keep up with the demand until rail service began to decline after World War II. Sometime during the 1980s, the yard was abandoned. Today, the complex has been placed on the National Register of Historic Places and has been saved from the wrecking ball. The facility has been repurposed and is currently being used as an office park. This complex is one of the few remaining examples of a roundhouse facility in the United States.

The Imperial Brewing Company was located at 2825 Southwest Boulevard. The facility exceeded the initial building costs of $50,000. The brewery could produce an estimated 50,000 barrels per year. The Imperial Brewing Company produced two lager styles, Imperial Seal and Mayflower. A stable was built in back of the property in 1902 to provide a local means to distribute beer. In 1904, a 250-ton ice-making plant was added to the brew house. When Prohibition was enacted, the brewery was converted to a flour mill and functioned in that capacity until the mid-1980s. When Prohibition was repealed, the Imperial Brewing Company reopened down the street, and by 1938, it was sold to Griesedieck/Falstaff.

The building at 520 West Pennway was built in 1918. The architect was Ernest Olaf Brostrom. In 1919, Dr. Hans Jensen moved his business into the building. He manufactured veterinary biological, pharmaceutical, and surgical supplies. The building has two stone sculptures outside, aptly named *Biology* and *Chemistry* by artist Jorgen C. Dreyer. The Jensen-Salsbery Laboratories is still in use as a veterinary supply company.

This building once was home to Safe Way Supermarket. The building and market was located at Jefferson Street near 16th Street. It is unknown when the market closed. Today, the building has been repurposed into apartments after sitting abandoned for many years.

Above: The approximate site of the Keeley Institute.

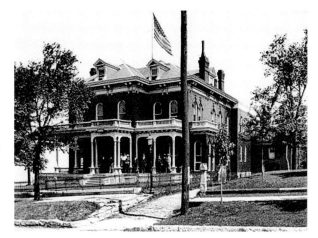

Right: The Keeley Institute was located at 716 West 10th Street. In 1879, Dr. Leslie Keeley collaborated with Irish Chemist John R. Oughton. The men claimed they had a cure for drunkenness. The cure was a series of injections of dichloride of gold. Keeley set up over 200 institutes across the country. Keeley died in 1900 and his institutes continued until 1965. It is unknown when this institute in Kansas City closed its doors.

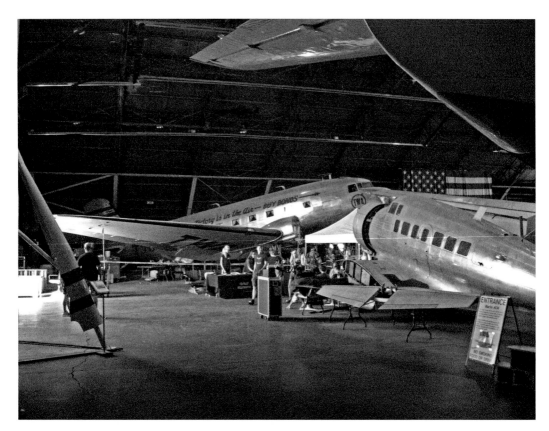

The National Airline History Museum is located at the former Kansas City Airport. It was founded in 1986 by Larry Brown and Dick McMahon. The museum was originally named Save A Connie, but it was renamed to better fit its exhibits. The museum highlights commercial aviation from the propeller age to now. The museum maintains five aircraft on site and several simulators.

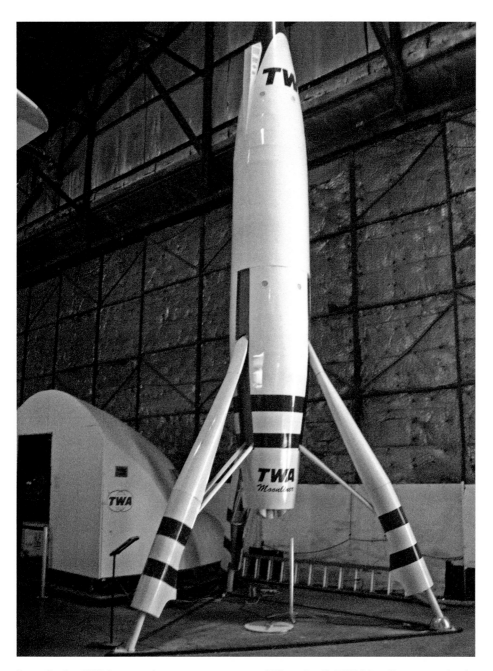

In 1956, after TWA became the corporate sponsor of Disneyland's TWA Moonliner attraction in Anaheim, California, Howard Hughes added a 22-foot-tall reproduction of the Moonliner on the northeast corner of the TWA Headquarters building. It was a promotional concept of what a TWA Moonliner would look like in 1986. In 1962, Disney and TWA ended their partnership and management had the Moonliner removed and sold it to a campground along I-70 between Kansas City and St Louis. In 1997, a lawyer from Columbia purchased the Moonliner and had it restored. It is now on loan to the museum for visitors to see.

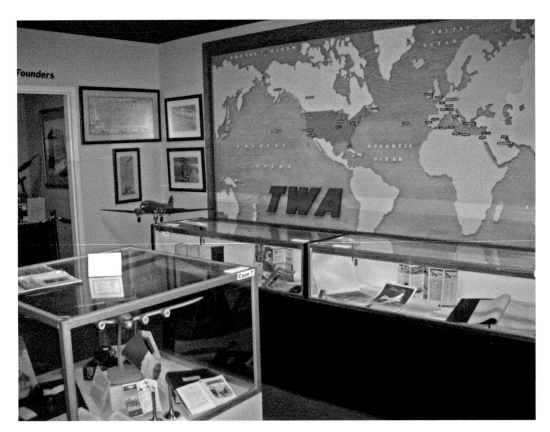

The TWA Museum is also located at old airport. The museum started as a collection of artifacts that were displayed near the TWA employee cafeteria at the MCI overhaul base. In the years that followed, TWA closed the Kansas City Administration building and the overhaul base as well as its training center in St. Louis. The museum items and displays came together at the Kansas City Expo Center. During the 150th anniversary of the Smithsonian, the collection travelled to twelve cities over two years as part of America's Smithsonian Exhibit. The museum now occupies the original building that was built in 1931 to accommodate the newly formed TWA Corporate Headquarters.

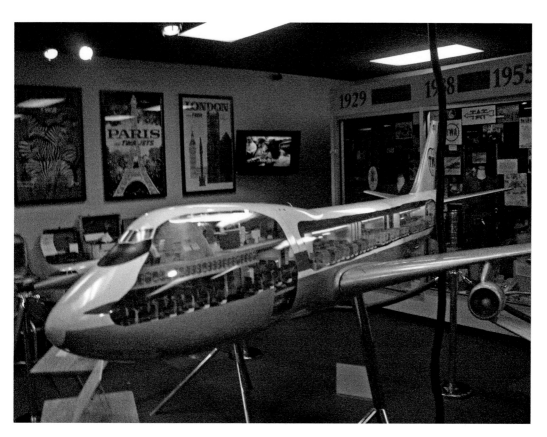

The Main Gallery is occupied by three large airplane models, complete with cutaway sections to show the interior of the planes. Lining the walls of the gallery are various artifacts including stewardess, agent, and pilot uniforms through the years.

Here we see Meadow and Danica Craig standing next to a 1970s cutout advertisement for TWA. The TWA Museum educates young children about the history of Kansas City's airline TWA and the evolution of passenger air travel.

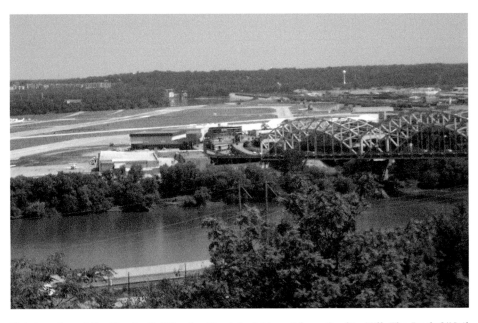

This is a view of the Charles B. Wheeler Municipal Airport from Quality Hill. The Buck O'Neil Bridge is on the right. The Fairfax Assembly plant (the former Fairfax Airport) is the big building across the Missouri River on the left. In 1927, New Richards Field as it was known was dedicated by Charles Lindbergh. Famed Notre Dame Coach Knute Rockne boarded a TWA flight from this airport, which eventually broke up in a storm as well as actress Carole Lombard's ill-fated flight. Today, the airport is primarily used by private charters.

The FBI has a long history of service in Kansas City. In 1920, it was designated one of nine divisional headquarters. The office helped pursue Bonnie and Clyde who committed some of their crimes in the division's territory. Kansas City Special Agent Raymond J. Caffrey was one of the officers killed during the Kansas City Massacre at Union Station in 1933. By 1960, the office had seventy-three agents and forty-three support staff and was handling 1,136 criminal cases and 461 other matters. During the 1980s, they played an integral part in the Strawman case that probed Mafia control in Casino Gaming in Las Vegas. The tradition continues today in their new headquarters building located at 1300 Summit Street.

Here we see Miss Bell, proprietor of Bells Barber Shop on 12th Street. She is holding her client Jerry Devaney. Behind them is the West Side Drug Store. By the 1970s, 12th Street was nicknamed "Sin Alley." The city government began to redevelop the area and swept out the businesses and the undesirable behavior.

This nondescript building located at 2139 Summit was the Swedish Society Building. It was designed by local architect Clifton B. Sloan who played a major role in the Swedish Community. The Building was a social hall as well. Today, the building is being renovated into loft apartments.

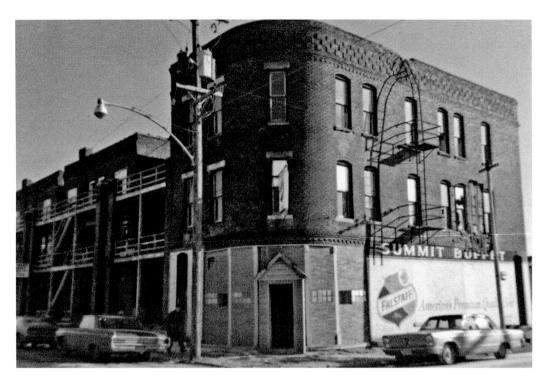

The Summit Buffet was located on the southeast corner of 16th and Summit Avenue. This local watering hole catered to the blue-collar workers of the neighborhood from the 1940s until the early 1970s when they closed. Notice the large Falstaff beer mural along the wall on Summit Avenue. The building housing the bar and the apartments next to it have both been torn down and the site is now occupied by apartments.

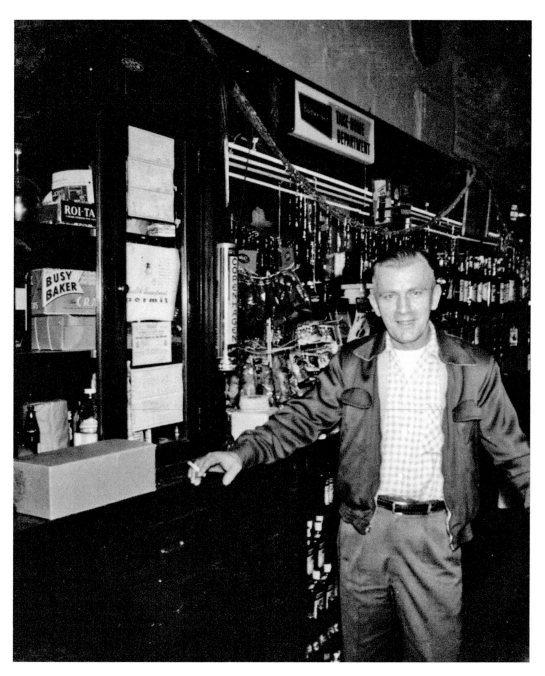

This interior view of the Summit Buffet shows owner John Ruby behind the bar. The patrons still came to the bar long after moving out of the West Side to see John and other friends from the neighborhood. Even though the bar was officially named Summit Buffet, many affectionately referred to it as Rubes.

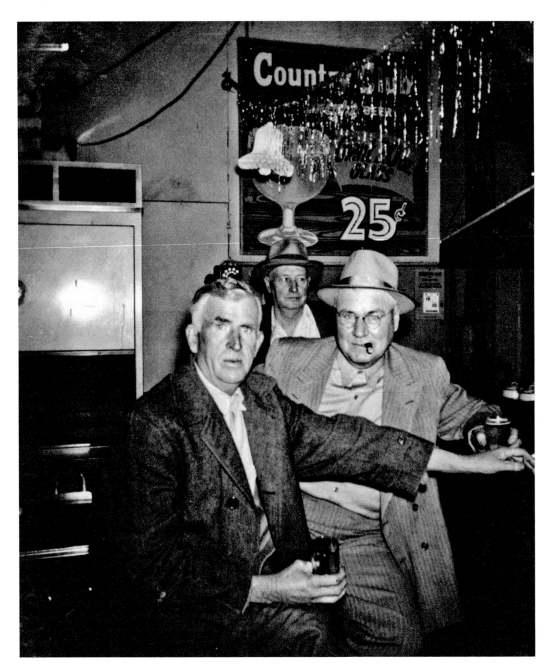

Here is another interior view of the bar. Marky Devaney and friends are enjoying each other's company. Urban renewal brought about the decline of many mom and pop-owned businesses like the Summit Buffet, leaving former residents with only fond memories.

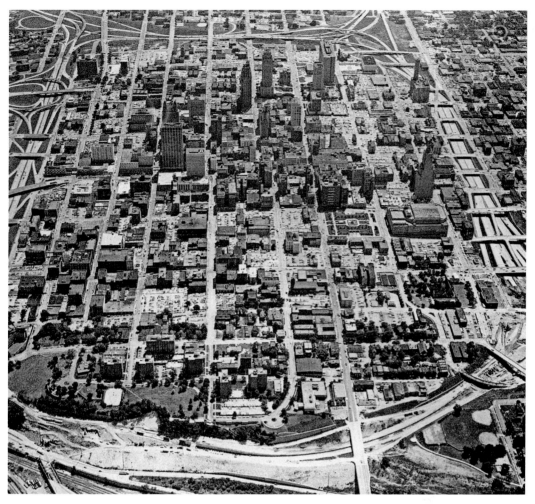

This view from Jefferson Street near 16th Street shows the highway system that was built during the 1960s, which devastated the West Side. The highway almost completely isolates these West Side neighborhoods from the rest of the city.

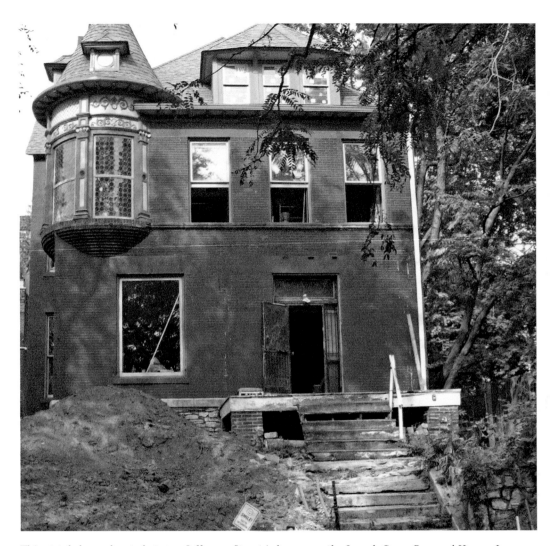

This stately home located at 1704 Jefferson Street is known as the Joseph Grear Peppard House. In 1887, he began the J. G. Peppard Seed Company with $10,000. He built this home the same year in the Queen Anne style. His sons operated the business after his death in 1932, until they sold it sometime in the mid-1950s. This is one of the few remaining architect designed homes in Mulkey Square. It has recently been sold and is now being lovingly restored.

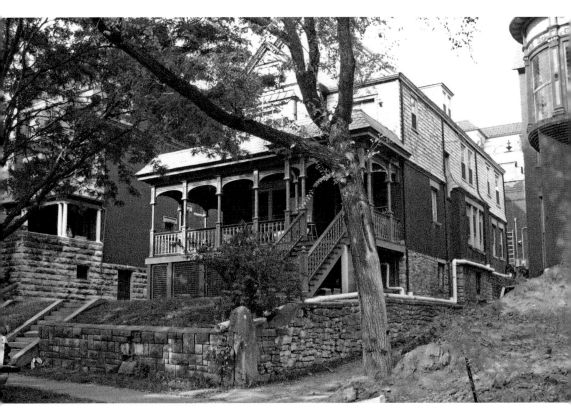

Many of the stately homes on Jefferson Avenue have been restored to their former splendor. However, many more were unable to be saved from the wrecking ball due to progress and neglect.

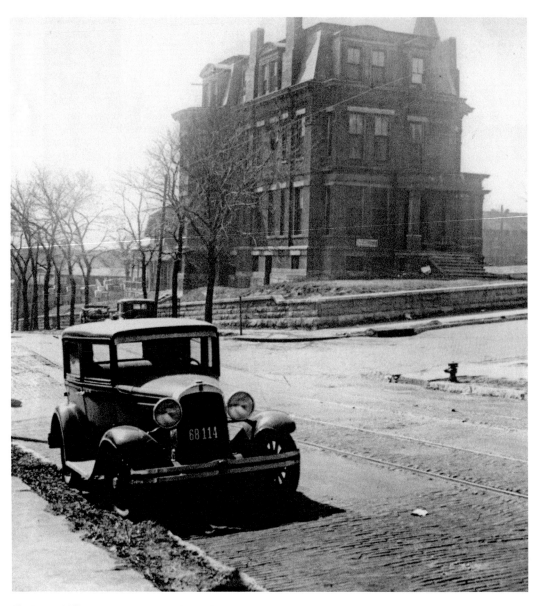

The Major William Warner House is located at 1021 Pennsylvania Avenue. The home was built in 1880 by Major William Warner who fought in the Civil War in Tennessee under General Ulysses S. Grant. Major Warner came to Kansas City after the war and setup a law practice in 1865. He spent a total of forty-four years in politics and was elected U.S. Representative from the 5th Missouri district and appointed U.S. District Attorney for western Missouri by President Chester A. Arthur. He resided in this home with his wife and three children. He died in 1916. The home has since been torn down.

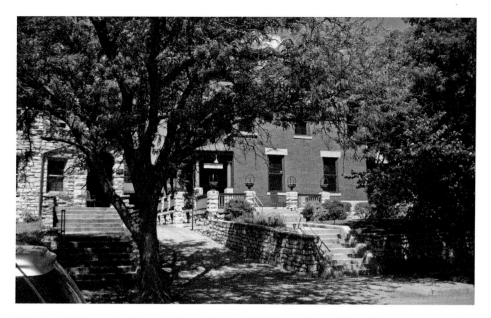

This beautifully restored home is located at 1728 Jefferson Street. It has thirteen rooms and is constructed of brick in the Neo-Classic design. The home was originally occupied by Charles Murdock, a dealer in seeds and spices. Today, the home is the Jefferson House Bed and Breakfast. Peter and Teresa Robinson are the proprietors of the Jefferson House Bed and Breakfast. They purchased the property in 2008 after falling in love with the community of the West Side. They lovingly restored the home, bringing it back to its original beauty, which took two and a half years to complete.

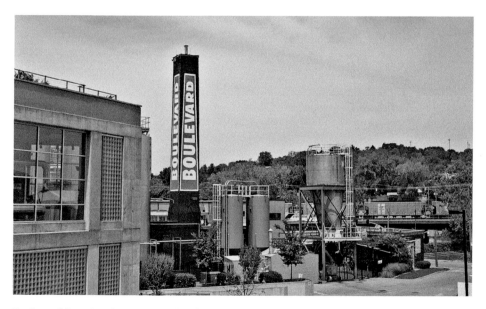

Boulevard Brewing Company on Southwest Boulevard currently occupies brick buildings that once housed laundry services for the Santa Fe Railroad. Founder John McDonald lived and worked in the building all the while converting the building to a modern brewery. In 1999 and 2003, the company expanded and increased its production capacity by 60,000 barrels per year, thereby returning beer brewing to Kansas City.

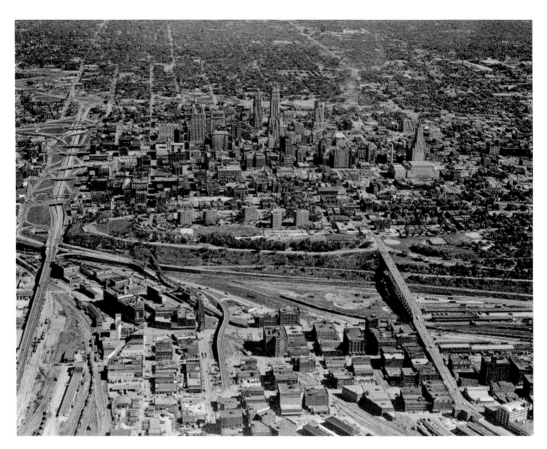

This aerial view of the West Side shows the freeway loop almost completed. The final piece to be completed is where Kersey Coates Drive once was. It is easy to see in this photograph how the West Side was cut off from the rest of the city when the highway system was put in place.

OPPOSITE PAGE:

In a small park located in the heart of the former Garment District is a fountain and a 19-foot steel needle and button. The sculpture was erected in 2002. It was placed here to acknowledge the contributions of the garment workers and companies that contributed to the economy of Kansas City and its glory days as a garment industry that was second only to New York City.

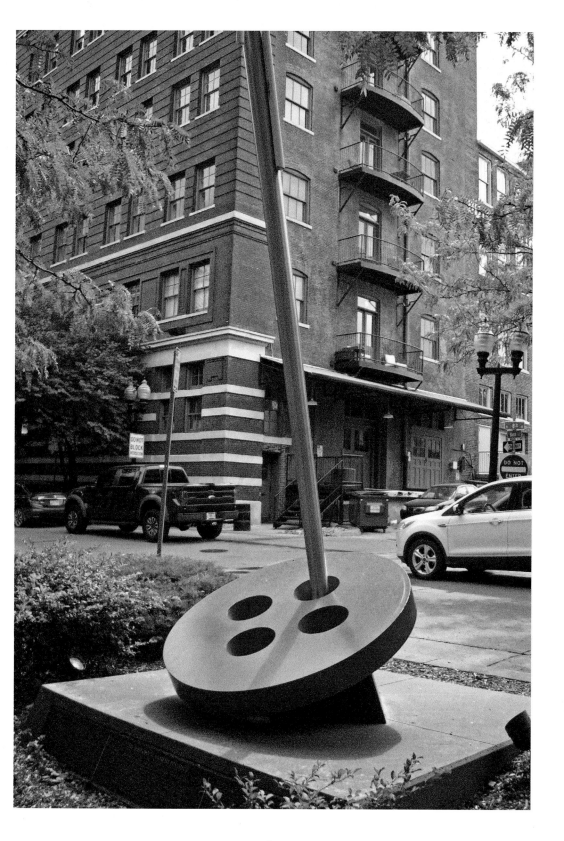

Pictured here is Alberta May Ross, who came to Kansas City in 1930 with her three children from Pitcher, Oklahoma, because her husband found employment here. Mrs. Ross, like many others, settled and raised her children on the West Side. She worked in many of the garment companies making a better life for her family.

This fountain is across the street from La Posada Restaurant. Its vibrant colors are representative of the areas rich Mexican and Latin heritage.

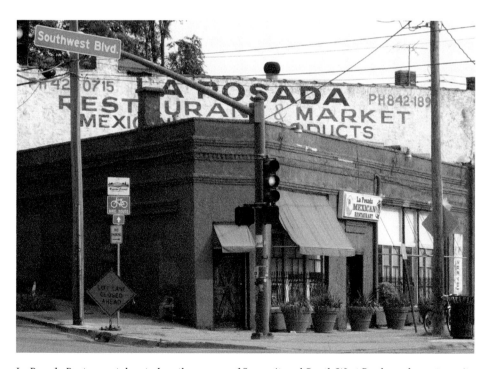

La Posada Restaurant, located on the corner of Summit and South West Boulevard, can trace its roots back to the 1940s. This is one of the first Mexican restaurants in Kansas City. People still come from all over the city to enjoy the cuisine.

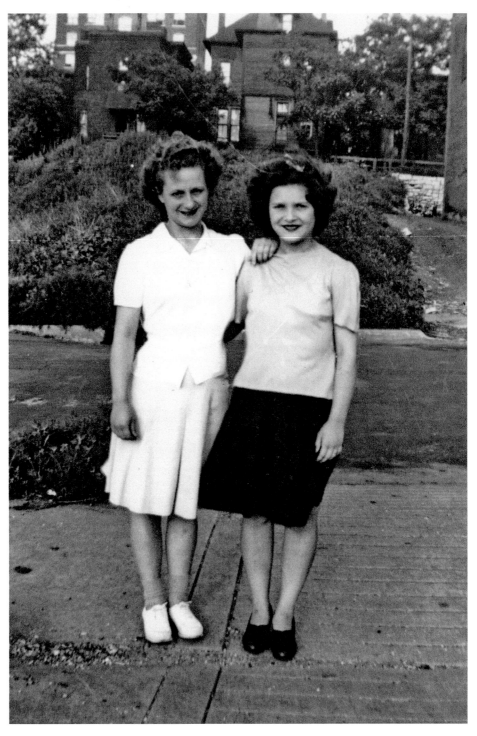

Sisters Dorothy Ross and Helen Ross pose for a picture on the West Side. These two women were raised, educated, and worked on the West Side.

An aerial view of Southwest Boulevard in 1953. This view is looking north from 25th and Summit. Not much has changed except for the addition of the Boulevard Brewing Company and some more upscale restaurants. For the most part, this area has retained its industrial feel.

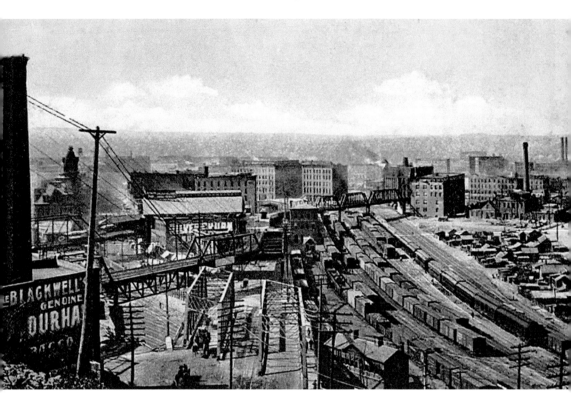

The West Bottoms never fully recovered from the 1951 flood, and by the 1990s, when the cattle industry had left, the West Bottoms became a ghost town. The area still looks like it did in the 1800s. The area has seen a resurgence in recent years as antique dealers and single professionals have rediscovered the area. This photo is from the early 1920s.

OPPOSITE PAGE:

Above: This is the fountain at the park memorializing the former Garment District. During the nicer weather, you can find people who live and work nearby eating their lunch in the park by the fountain.

Below: This view of the West Side in the early 1950s shows the construction of Southwest Trafficway. The supports look like hurdles in the photograph.

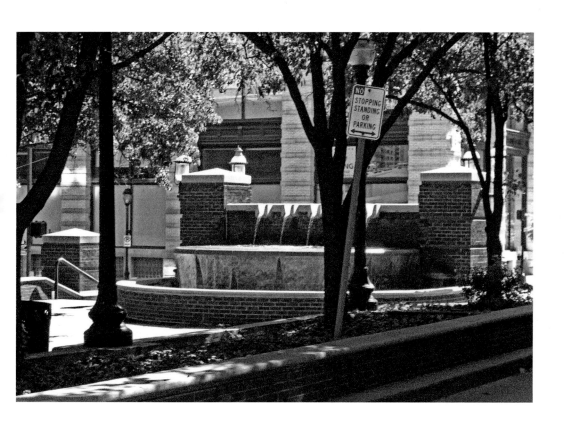

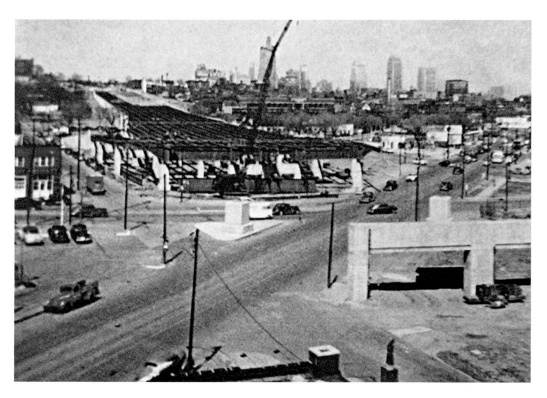

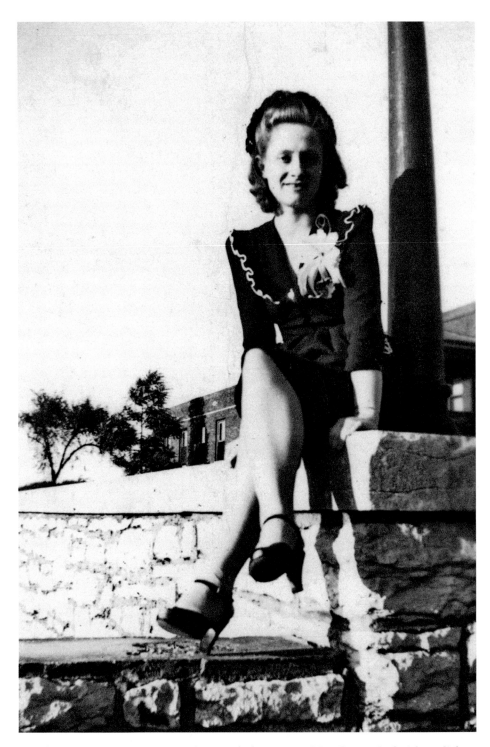

Dorothy Ross Devaney stops to pose by a gas-lit lamppost at West Terrace Park. A lamp lighter would walk through the park at dusk lighting the lamps, then come back at dawn snuffing them out. The gas-lit lamps were discontinued by the mid-1950s.

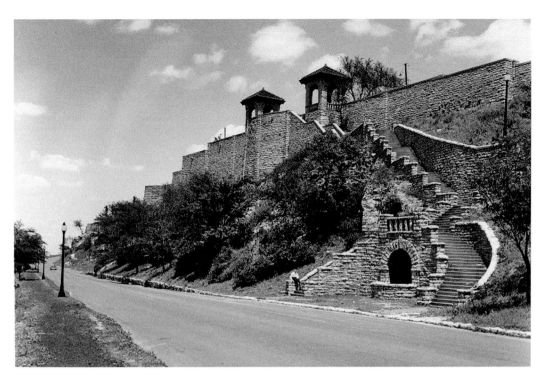

This 1930s photograph taken from West Terrace Park shows a much different landscape than we see from the same vantage point today. Kersey Coates Drive has been replaced with a super highway. However, the park still has one of the most beautiful vistas in Kansas City.

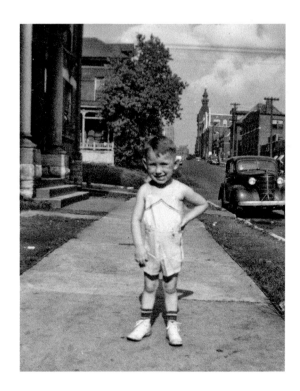

Here we see Jerry Devaney in the late 1940s. In the background on the right-hand side is the spire to Cathedral Church. Notice the homes that were all around the area during this time; within thirty years, the area would become unrecognizable.

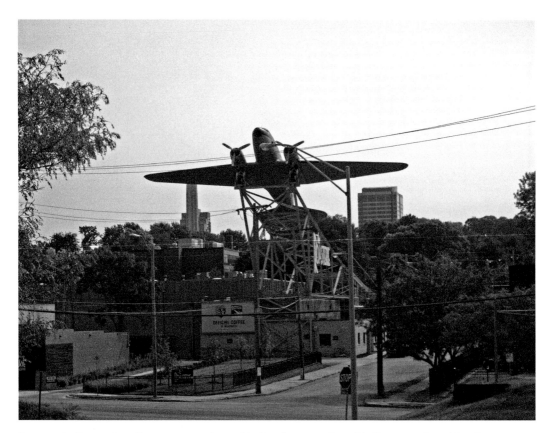

In 2007, the Roasterie coffee company relocated its headquarters from Madison to 27th and Southwest Boulevard. In 2012, the company hoisted a historic DC-3 above the factory on Southwest Boulevard, forever changing the Kansas City skyline. After the flood of 1951, Southwest Boulevard fell into decline as many companies opted to move out of the floodplain. Companies like Roasterie have helped to revitalize the area in recent years by bringing jobs and showing other businesses the possibilities that the area provides.

This photograph of an apartment building on West 17th Street was taken sometime in the early 1920s. Apartment buildings like these suffered from years of neglect and deterioration until recently. Today, they are being rehabilitated and many families are moving back to the area and rediscovering the joys of city living.

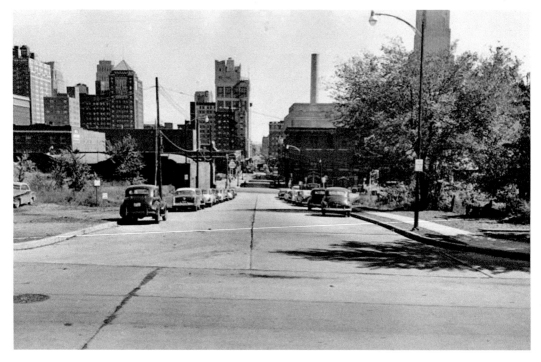

This view looking east on 13th Street from Washington in 1952. The former bowling alley can be seen in the left of the picture. After years of decline, the area has been undergoing a renaissance thanks to urban renewal.

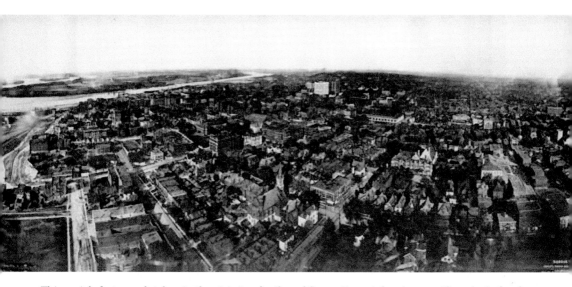

This aerial photograph taken in the vicinity of 13th and Summit was taken in 1907. If you look closely enough, you can see horse stables adjacent to several homes. Although the area has undergone major changes over the past 111 years. The dry goods, cattle, and garment industries have all left and been replaced with offices and tech companies, yet the remaining neighborhoods have retained their quaint charm, and through preservation and renewed interest in the historical significance of the area, the citizens of Kansas City can still enjoy the first suburb of the city.